Scaylea on Photography
HOW HE DOES IT

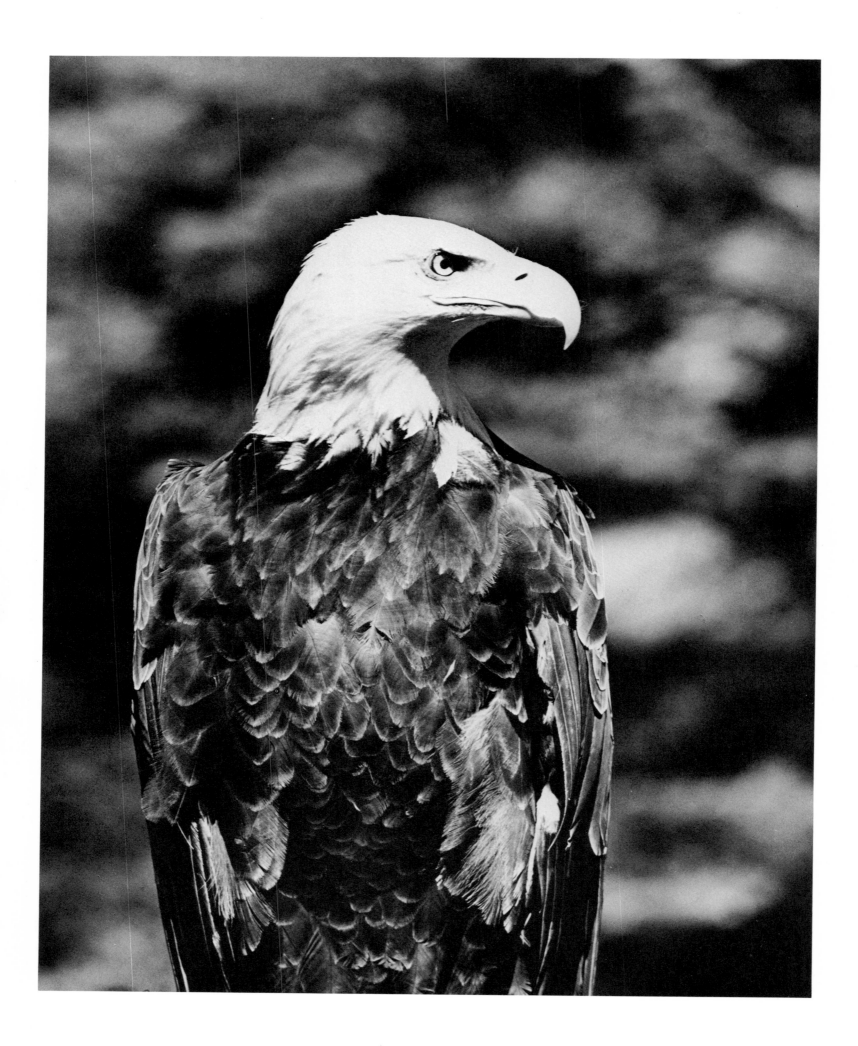

Scaylea on Photography
HOW HE DOES IT

By
Josef Scaylea

The American eagle is a magnificent subject. At Friday Harbor in the San Juan Islands, the eagles are not as wary of man as in more remote wilderness areas. Their self-confinement to the island also makes it easier for the photographer.

From early spring to early autumn eagles abound in goodly numbers. The Cattle Point area where eagles ride the air currents hunting for rabbits is especially good for sighting and photography.

The long and extra long telephotos are an absolute must for eagle shooting. It is unlikely you will ever get close enough to use even a medium telephoto effectively.

The eagle here is perched on a low snag against a background of fir trees. The fir boughs with light filtering through form a neutral background. The neutral background is dark enough for the white head and light enough for the dark feathers. Shallow depth of field eliminates background detail, emphasizing the sharp focus on the eagle.

1/500 SEC. F 8
HASSELBLAD CAMERA

TRI X FILM ASA 400
500 MM ZEISS TESSAR LENS
NORMAL DEVELOPMENT IN D 76

A SALISBURY PRESS BOOK
A division of Superior Publishing Company
Seattle, Washington

Library of Congress Cataloging in Publication Data

Scaylea, Josef.
 Scaylea on photography.

 "A Salisbury Press book."
 1. Photography — Handbooks, manuals, etc.
 I. Title.
 TR146.S37 770'.28 76-2521
 ISBN 0-87564-014-1

ABOUT THE AUTHOR

The son of immigrants from the mountains of northern Italy, Josef Scaylea grew up in Glastonbury, Connecticut, the youngest of six children. As he watched his mother and father turn scrubland into vineyards and orchards, young Josef developed what he considers a peasant approach to life. Simplicity, honesty, and good hard work were the heritage of his people. He applies these qualities both to his photography and his way of life.

This man knows himself and his limitations perhaps better than most. He makes no pretense at being an artist, has indeed a contempt for the "glamour photographers." He refuses to enter into the field of the so-called "socially significant" photography, does not wish to change the world, claims to have no message for mankind. He is fiercely loyal to the Northwest, disclaiming any desire to leave its boundaries either for pictures or audience.

His simple aim is to record with his camera the beauty in nature and the nobility in the work of man . . . for the lasting pleasure of everyday people. "This is where I find my reason for being, my fulfillment, even my religion. If my pictures give pleasure to people, that's enough for me."

Although he has had the opportunity to do portraits of presidents, he particularly likes to take pictures of people of the soil and people who work with their hands. "I have as much respect for a good carpenter as I have for an artist," he says. "The good Lord just gave him a different field in which to work—a different medium."

A vital, dynamic and energetic man, Scaylea, works no schedule. He arises early to check out the moods of the mountains and the mists of morning. Often he continues working long into the shadows of evening. From the fields to the dark room and back out again, the man moves with an urgency that generates an aura of excitment.

Scaylea began his photographic career in New England after attending a photography school in New York in the mid 1930's. He believes that it was the beginning of the golden age of photography. During World War II he served as an Air Force photographer working in the South Pacific and eventually in the Pacific Northwest.

Since 1949 he has been chief photographer of the *Seattle Times*. During his career there, he has been named West Coast Photographer of the Year twelve times, One of the Ten Outstanding Photographers of the Nation seven times.

His pictures have appeared in Holiday, Life, Sports Illustrated, Newsweek, Saturday Evening Post, America, and all leading publications.

He has had one-man shows at the Frye Museum, The Museum of History and Industry, The Pacific Science Pavilion, The Seattle Public Library, The Seattle Center House and Expo '74.

Altogether he has won more than one thousand commercial, pictorial, and press awards.

"But the real judges of my work," says Scaylea, "are not the professionals but the people who view my pictures. For that reason, I cherish a recent award from the Friends of the Library of the Tacoma Community College. It was the 1974 Distinguished Service Award presented for outstanding cultural enrichment of the area by a group of citizens, none of whom I had ever met."

With this book, his third, Josef Scaylea once again speaks to and for all the people of the Northwest. He speaks through his pictures with an articulacy not known in the world of words. He captures the glory of the great Northwest, particularly in its majestic mountains. He gives us the peace of the woods and the waters. He shows us the strength of our people, the world of our wildlife. Then he tells us how he did it.

For a photographer of this man's genius to share his secrets of photography is a tribute to Josef Scaylea's aesthetic nature. Although he wouldn't say so, there are many who feel he creates poetry with his camera. Now you can do it too.

Patricia Latourette Lucas, Editor

THE CREATIVE PHOTOGRAPHER

In the forty years I have been a photographer, I have often been asked what qualities produce a creative photographer.

A truly good, creative photographer is indeed a rarity. He is a composite of the pictorialist who reigned in the 1920's, the documentary recorder who dominated the 1930's, and the photo journalist who has prevailed from the late 1930's to this day.

He must be an extremely aware and informed person, alert and responsive to all that goes on. He must be sensitive and artistic, and yet be realistic about his subjects and how to present them photographically. And, of course, he must be a master craftsman able to employ all the tools and techniques required to produce outstanding pictures.

There are three factors which ultimately will determine the success of the creative photographer.

First, he must have an inborn artistic talent.

Second, he must possess a compulsive drive to pursue and present his pictures to a great number of viewers.

Third, he must have the judgment to select subjects either interesting or artistic enough that the viewers are compelled to respond.

A photographer who possesses all three of these qualities—talent, drive, and judgment—is assured of success.

THE SUBJECT

The major factor in producing good pictures always has been and always will be the subject. No photographer can create from a dull subject a picture that will hold the interest of the casual viewer. He may with superb technique produce a picture that by its technical excellence will impress other photographers. But technical mastery alone is not enough. Technical mastery in combination with good subject matter takes us a long step further.

To consistently produce good, exciting pictures, we must look to a dedicated photographer. He must devote himself to subjects that have dramatic pictorial potential. They must be subjects which are suited to his own personal temperament, aesthetic values, and interests.

I shall always remember a photographer internationally famous for his landscapes whose superb craftsmanship and precise compositions were a guide and inspiration in my formative years. This photographer was thrust by his fame and success with landscape photography into the area of commercial illustrations which he did very, very badly. He even ventured into portraiture which was even more disastrous.

Often editors or ad agencies will commission a photographer who has made a considerable reputation in one field to work in an area for which he is totally unqualified. The photographer should know himself and avoid assignments or commissions that are personally unappealing to him.

I am often asked, "What would you really photograph if you had a choice?"

"Exactly what I am photographing now" is my answer. Any subject, any activity that has the potential for a good pictorial presentation will draw my attention.

Although I have a reputation as a mountain photographer, I am not in the true sense a mountain photographer. Most of my mountain pictures are distant scenes, depicting mood and feeling. Mountains are certainly a great subject for any photographer, many of whom make a profitable career out of that one subject. However, few photographers of talent would be happy working merely with one subject.

The last thing I would wish to do as a photographer is roam the Northwest or even the world recording all the scenic highlights.

Most particularly, I enjoy photographing people engaged in activities or sports where nature provides a majestic backdrop. Farming, logging, skiing, sailing, and commercial fishing are some of my favorites.

On the other hand, personally I find little photographic excitement in the spectator sports, baseball, football, and basketball. I find none whatsoever in the only sport I enjoy as an active participant, tennis.

I am very often asked whether I prefer to use color or black and white. I shoot an equal amount of each. I have no preference. It depends on the subject and the use for the picture.

Surely it is ridiculous to shoot most flowers in black and white. Just about any catalog product with color is better shown in color. Certainly rainbows and sunsets are less effective in black and white. Your own good judgment will usually help you in choosing the more effective medium.

Another guideline is experience. If you are a beginner with little understanding or feeling for lighting, use color. Color in itself makes a picture appealing to the eye. Color will influence the viewer to overlook flaws in the picture that would be devastating in black and white. Color photography is much easier to handle in every way. It is better for education and entertainment.

Black and white, however, is the more artistic, the more forceful medium. If you wish to make a powerful, dramatic presentation, you can do it ever so much more effectively in black and white.

Be it color or black and white, the talented photographer will find a wealth of good pictorial subjects wherever he is located as long as he remembers that the subject must first of all lend itself to a dramatic and interesting interpretation or it must have considerable human interest.

COMPOSITION

The composition of your photograph should be simple and clean with one center of interest.

I am aware of all the traditional rules of composition and generally I abide by them. However, I no longer consider composition the major factor in good photography. Few, if any, viewers care or even notice a flawless composition. Perfect composition adds no strength or interest to a picture. Common sense in arrangement will make a picture pleasing to the viewer.

Some aspiring photographers look upon composition as the magic ingredient to success. Some instructors make much of composition with involved diagrams of leading lines, circles, and symbols. If there is a center or merely a point of interest in the picture, the eye will find it. If no point of interest exists, the eye will roam and quickly give up on the picture.

My definition of good composition is a well-arranged, simple presentation of a good subject where the photographer shows good pictorial judgment, technical expertise, and all-round professional craftsmanship.

Actually, good composition is the strongest way to present the subject. The principles involved in it apply to everyday living as well as to any work of art. The furnishing of a home or an office, the way we dress, are examples. Pictures that contain too much are confusing and actually annoy the viewer. The simple picture is the strong picture, the effective picture.

Above all, when you are ready to make your way as a photographer, do not look for subjects only because they will produce a textbook composition.

Many photographers use cropping in the enlarger to eliminate unnecessary and confusing distractions in the negative. Whenever possible, I do my editing in the viewfinder of the camera. This has the advantage of utilizing all of the negative area in enlarging which means better quality in enlargements beyond the 8 × 10 size.

NEWS PHOTOGRAPHY

The young photographer's best route to becoming a press photographer for a metropolitan daily is to equip himself with a police radio. He must learn to selectively monitor and diligently cover every accident and fire of any consequence in his general area.

Editors are most receptive and encouraging to a photographer who consistently comes up with spot news pictures. He will most certainly be considered when a staff opening occurs.

The best and most effective showcase for a capable young photographer is exposure in his local newspaper. No amount of commercial advertising can be as effective. If his published work consistently shows excellent craftsmanship and

artistic merit, the viewer will recognize this and respond accordingly. Ad agencies will seek him, as will others searching for a better presentation of their product.

I can't stress enough the importance of free-lance exposure in the local newspaper, both as a means of becoming a staff member and also in establishing yourself as a successful photographer in the community.

Free-lancing in the *Hartford Courant* and the *Hartford Times* brought me my first recognition as a photographer in the 1930's. Free-lancing in Seattle during World War II led to my present position with the *Seattle Times*.

BOOKS

I believe it is safe to say that every photographer has in his mind the idea to someday publish a book. Few ever achieve the goal, or even make a serious effort.

However, to those among you who are compulsive about a book, there is a way. Select a subject you know thoroughly and pursue it photographically to an extreme degree. Assemble a pictorial record of the subject that is complete, covering every facet.

Publishers are always interested in this approach, especially if it is a subject that has never been published in depth before. In a situation such as this, the publisher realizes that he has an audience of everyone interested in the subject. Consider the How To Do It books, the What To Do, How To Build, Where To Bike, Where To Walk, Where to Fish. The list is endless.

Know your subject and make it regional. Photograph it well. Write it yourself, or work with a capable writer. Fancy prose is not required, but accuracy and completeness are essential.

Unless you have a large reputation and truly exceptional pictures, it is very difficult to find a publisher who will accept a large, lavish picture book for publication. The expense now involved in producing a high quality picture book makes it impractical without a grant or subsidy. However, for the talented pictorial photographer, this ultimate goal is one well worth striving for.

EQUIPMENT

The formula for great pictures is the same today as it always has been. To be successful, the photographer must be where the pictures are with the proper equipment.

The best camera for general photography as well as photo journalism is the 35 mm Single Lens Reflex, universally popular among the professionals. It is the most simple, versatile, and is practically foolproof as far as getting the picture on film.

If you are now using the 2¼ square or the 4 × 5 format and getting good results, do not change. I use all three. My order of preferance is the 2¼ × 2¼, the 4 × 5, and the 35 mm SLR.

There is a great deal to be said for the old-fashioned 4 × 5 press camera. The large negative allows a print quality that cannot be matched by the smaller cameras.

With the 35 mm SLR system, I recommend the 28 mm wide-angle lens, the 50 mm normal lens, the 105 mm lens, and the 200 mm telephoto lens. This equipment allows coverage of almost every possible assignment in photography.

The over-equipped photograher is at a greater disadvantage than the under-equipped. You do not need the motor drive, the super wide-angles, and the super telephotos. Nor do you need the zoom lenses.

For black and white outdoor photography, I recommend only the G filter. No filters are needed for outdoor color photography.

I much prefer printing with graded papers. If a print looks good on number 3 contrast paper, try number 4 paper. It may be even better.

I use D 76 and Accufine film developers.

LIGHTING

No other technical phase is as important to the photographer as lighting. Lighting—how to use it, how to make it work for you—is the key to photography. Once you really begin to see light, then and only then can you make it work for you. Your pictures will command notice, for it is light that puts life in a picture.

Bright sun will produce your surest but least interesting pictures.

The warm, mellow light and long shadows of late afternoon give a landscape or a portrait the feeling of a Flemish painting.

Shooting in the low light levels will produce the best mood and dramatic shots.

Avoid flash. For the most part, it is unnecessary.

I use the Gossen Luna Pro light meter and am constantly amazed at its scope, accuracy, and ease of operation. There are various methods of taking a reading in the manual but the only one I use is to hold the meter ten inches from the subject. If it is a distant landscape, city scene, or night scene, I point the meter at the subject.

The meter is especially necessary for night photography. While it is possible to estimate daylight exposures quite easily, night photography requires the use of a good meter. With a meter, night photography can actually be easier than daylight shooting.

THE PHILOSOPHY OF PHOTOGRAPHY

A photographer's work is, of course, most revealing of the photographer himself. What you photograph and how you use photography reveals your true personality, your taste, your thinking, your intellect. Your photography can be a testimonial to your character, or a devastating insight into your psyche.

Some photographers are willing to exploit any situation or person with gimmicks and distortions, fish eyes, and wide-angle lenses. Sometimes they are encouraged in this treatment by editors who demand sensationalism in photography. I believe this combination was responsible for the demise of the picture magazines.

I object to the ugly and the obscene. I urge you to leave the four-letter words out of photography. The overkill on sports, sex, and violence has now made boring cliches of these once prime subjects.

My advice to future photographers is to maintain your integrity. Seek permanence. I continually ask myself, "Was this a good picture yesterday? Will it be a good picture a hundred years from now?"

Keep it simple. Keep it straight. Keep it honest.

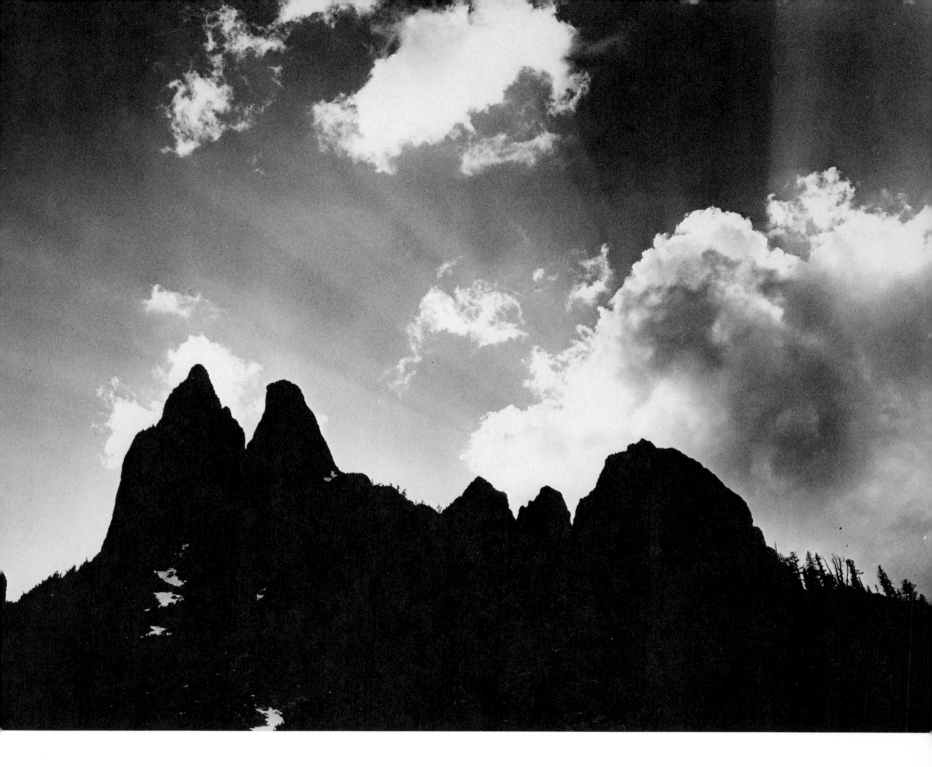

Mountains are a great subject in themselves and many photographers are content with an objective recording of our peaks.

I always seek a subjective approach where mood becomes more important than the scene itself. I forever watch for the unusual clouds that mountains attract. Here clouds, combined with the late afternoon sun behind them, create a dramatic mood picture of Liberty Bell, a North Cascades peak.

To achieve this effect, expose for the sky. If the exposure reading was taken on the peak, there would be detail in the peaks but the sky would be washed out, the clouds lost, and the mood destroyed.

To further enhance the effect of the sky, a G filter (orange) was used.

1/500 SEC. F 22 120 TRI X FILM
HASSELBLAD CAMERA 250 MM ZEISS SONNAR LENS

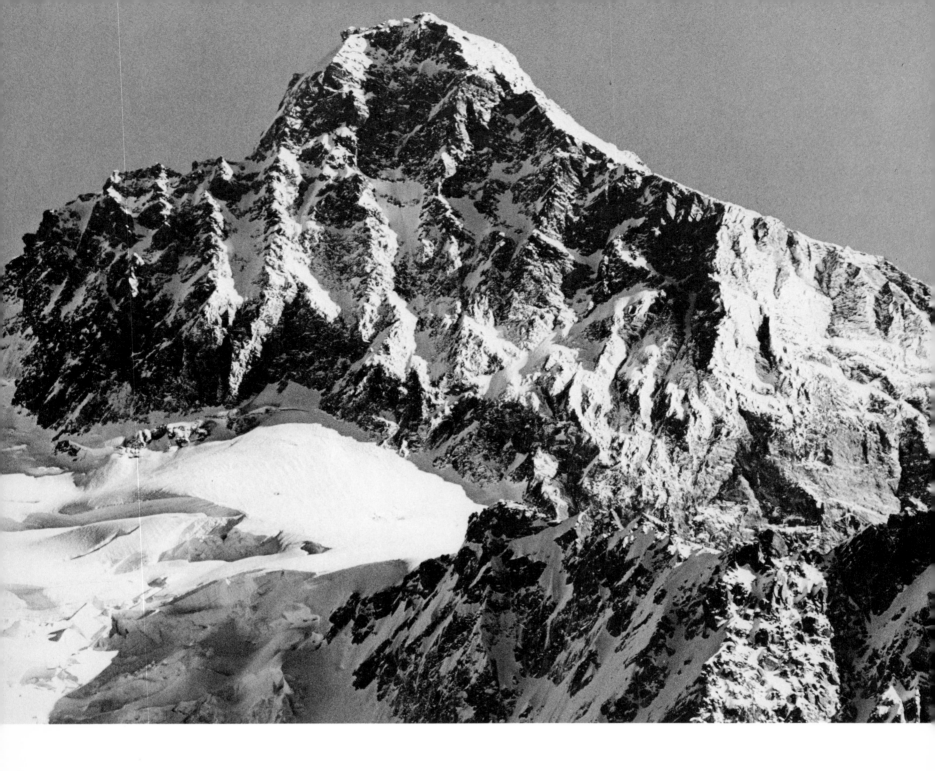

Here a straight, objective approach shows the ruggedness of the west face of Mt. Shuksan. I was never aware of this ruggedness until it was revealed by the low sun of a December afternoon.

The low sun striking the west face at an angle has the effect of studio cross-lighting, a technique used to show texture of fabric in an advertising illustration.

Frontal lighting flattens a subject. Sidelighting gives depth and modeling to the face of a mountain, as well as a human face.

1/250 SEC. F11 120 TRI X FILM
G FILTER 250 MM ZEISS SONNAR LENS
HASSELBLAD CAMERA

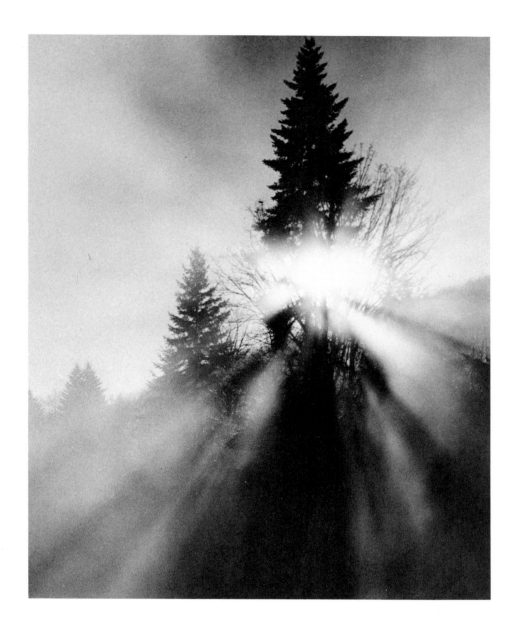

The fogs and mists of autumn and winter inspire my best landscape efforts. I usually wait until the sun begins to break through. Without the sun, the overall effect is dull, flat, and monotonous, lacking contrast and life. An orange or red filter further heightens contrast.

Unusual, dramatic effects can be achieved by using infrared film.

TOP
1/125 SEC. F 11
G FILTER
HASSELBLAD CAMERA
120 TRI X FILM
80 MM ZEISS LENS

BOTTOM
1/125 SEC. F 16
G FILTER
HASSELBLAD CAMERA
120 TRI X FILM
80 MM ZEISS LENS

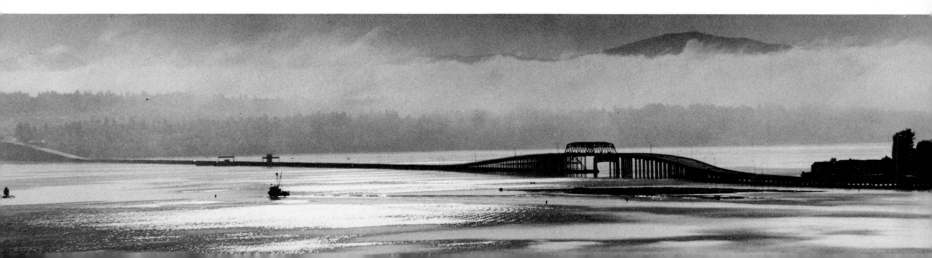

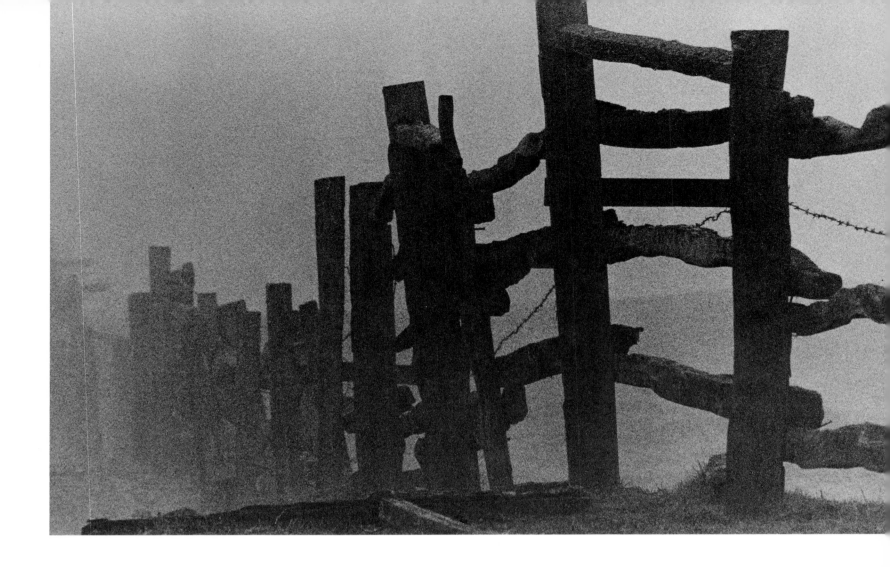

Fog eliminated what would have been a most distracting background. Fog gives the viewer no choice but to concentrate on the fence and the abstract design created.

A long telephoto lens produced the compression effect of the distant posts.

1/60 SEC. F 22	35 MM TRI X FILM
G FILTER	300 MM NIKKOR LENS
NIKON F CAMERA	

Fog works for the photographer other than aesthetically. After the heavy winter fog disappears, the atmosphere seems almost totally clear of haze and smoke, making long distance mountain views possible and nearby landscapes sharper and brighter.

1/50 SEC. F 16	SUPER PANCHRO PRESS FILM
G FILTER	135 MM OPTAR LENS
4 × 5 SPEED GRAPHIC CAMERA	

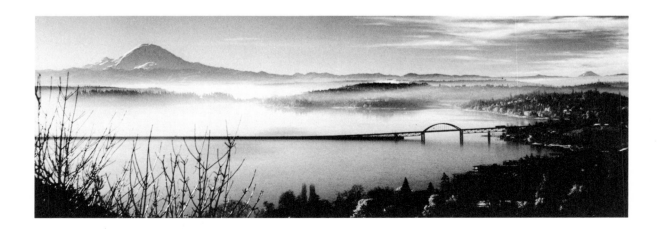

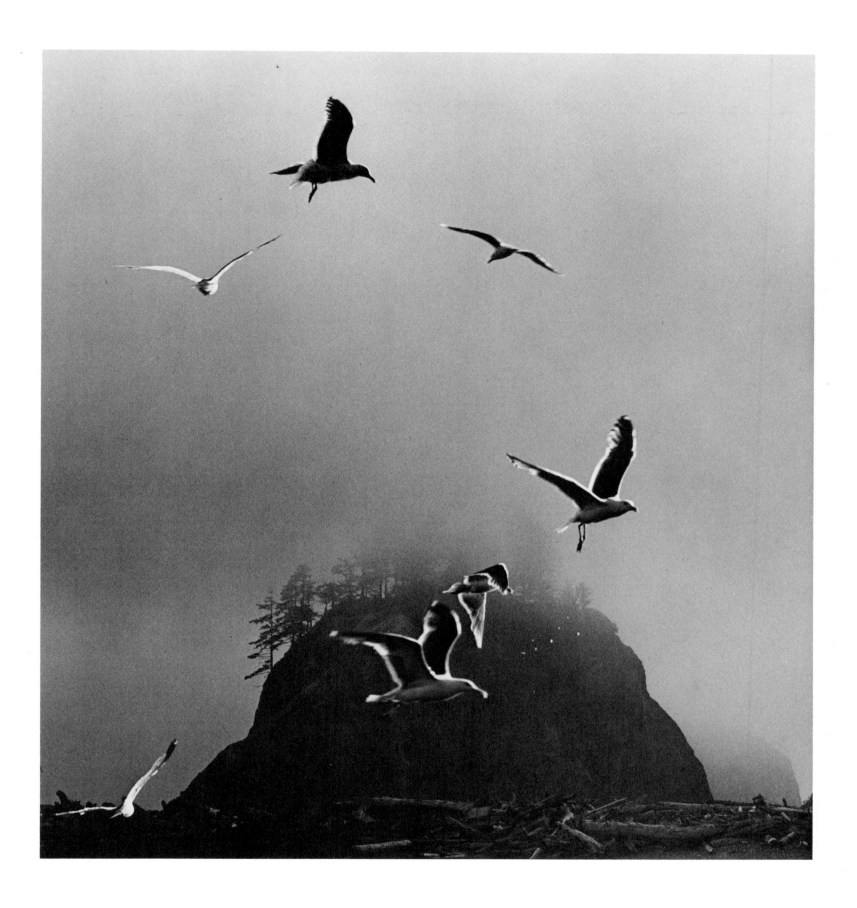

Heavy coastal fog cancelled our off-shore salmon fishing charter at La Push. However, sea gulls darting from fog to sun provided a much better subject than sports salmon fishing. A photographer must always be alert to options that may occur on any assignment at any time.

1/500 SEC. F 16 120 TRI X FILM
G FILTER 80 MM ZEISS LENS
HASSELBLAD CAMERA

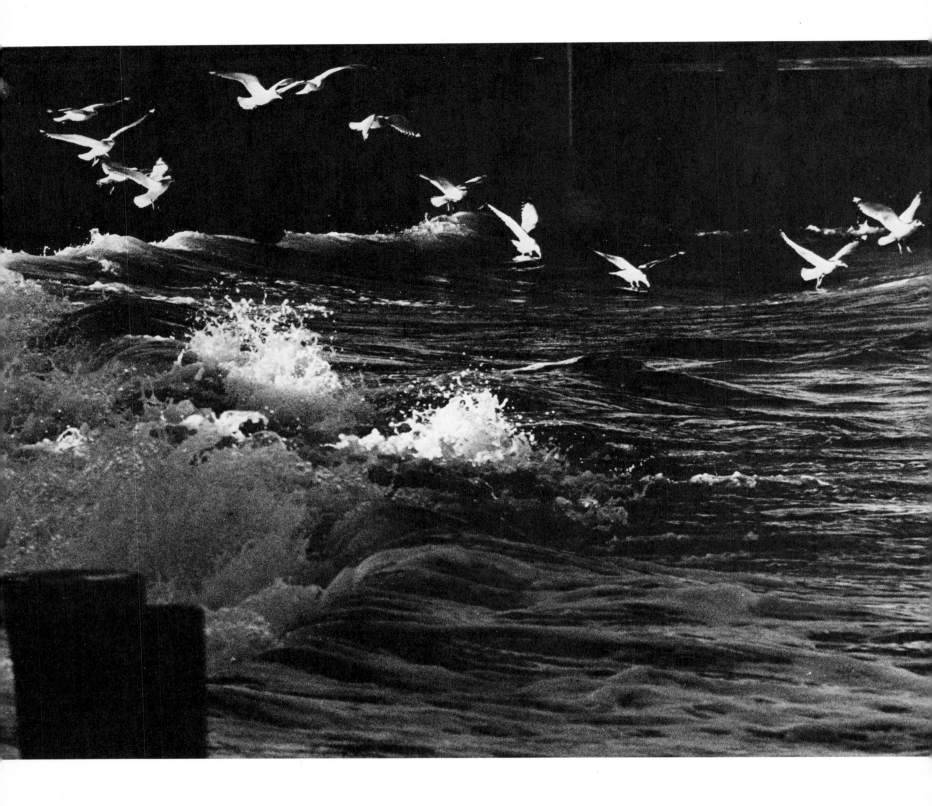

On a clear, cold, January morning, I rushed to Edmonds to shoot the snow-laden Olympic Mountain range with a ferry or other marine activity in the foreground.

Suddenly, low-flying, screeching gulls feeding in the rough surf and spotlighted by the low angle sun demanded my attention. The Olympics and the ferry boats would keep for another time. Never again would I or anyone else come upon gulls in such an arrangement and lighted so dramatically.

Reader response to this picture was intense. Many thought it was a sequence; others said it was a time-lapse technique; others assumed it was trick photography. As are all my pictures, it is a completely honest, single-exposure photograph. Again, as with many of my more successful pictures, I merely recorded one of nature's dramatic stagings.

1/1000 SEC. F 11 120 TRI X FILM
G FILTER 300 MM JENA LENS
PENTACON SIX CAMERA

On cold, frosty, November mornings, there are unlimited picture opportunities. The newspaper photographer has perhaps a chance to get one picture published.

This is the picture I submitted one such morning to give the readers of the *Seattle Times* my impressions of this glorious morning. The quiet, marshy lagoon, the wild life, the soft mists, and Mt. Rainier in the background provided all the necessary elements for a most pleasing picture to myself as well as the readers.

Composition wise, this is an overly busy picture with numerous points of interest, but the overall beauty and feeling of the scene overrides the flaws in composition.

I used a telephoto lens to bring in Mt. Rainier. With a normal lens, Mt. Rainier would be lost.

1/50 SEC. F 22
G FILTER
4 × 5 SPEED GRAPHIC CAMERA

SUPER PANCHRO FILM
360 MM TELE XENAR LENS

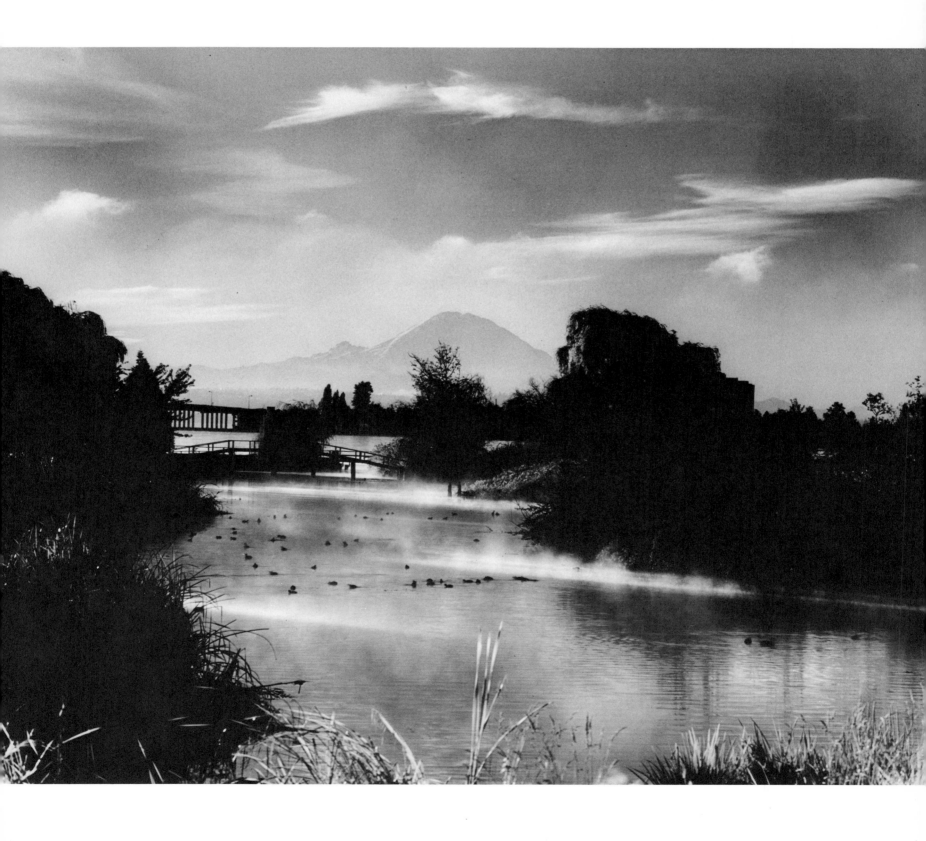

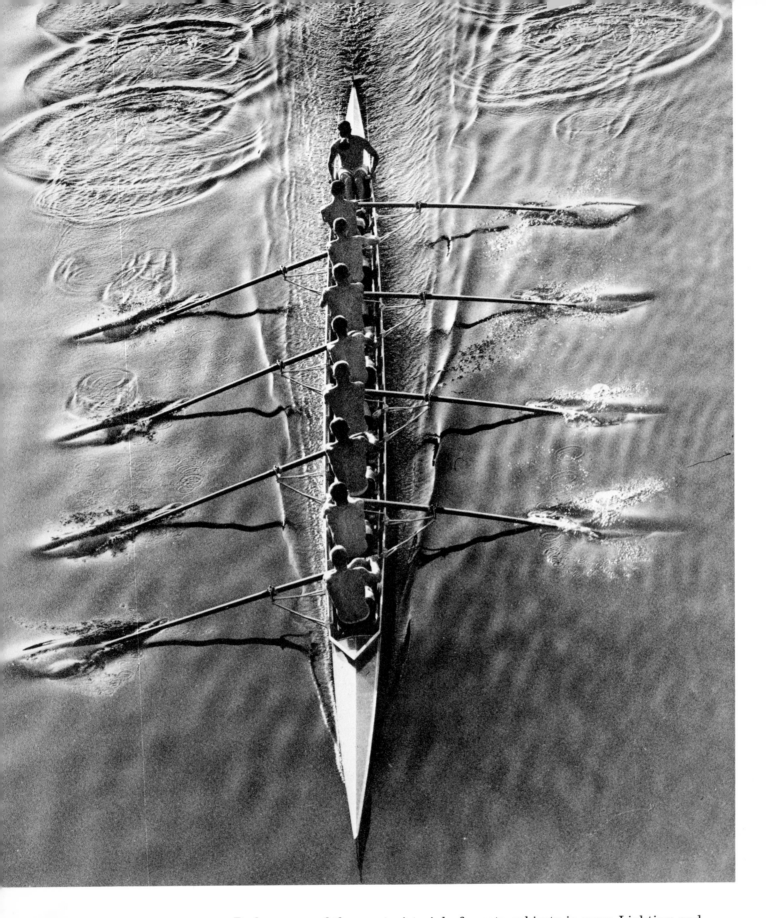

Perhaps one of the most pictorial of sports subjects is crew. Lighting and viewpoint are the main factors. The slim low-profile shells blend into the water when the sun is directly on them.

Here we see the ideal lighting and angle of view. The lighting was diffused backlighting from a weak, early morning sun. Strong, full sun, backlight would produce a stark silhouette effect, wiping out detail and texture.

This picture illustrates my concept of design, motion, and texture very well. It also portrays man and the elements. Purists will be critical of the bow of the shell almost poking out of the picture. In printing, I had the choice of leaving the proper space for the bow or eliminating the pools of motion behind the shell. It was an easy choice. The interest and motion created by the pools far outweighed my desire for correct composition.

1/400 SEC. F 8 135 MM OPTAR LENS
4 × 5 SPEED GRAPHIC DEVELOPED IN D 76
SUPER PANCHRO FILM

It was spring vacation and a beautiful day in the mountains. Hundreds of young skiers were eager to show off their skills. The word spread over the mountain that a Times photographer was shooting pictures at the top of Denny Mountain.

Skier after skier made a pass for the camera—all very good, all very similar. Suddenly, starting from a higher point and approaching at great speed, a skier flew off the lip, skis crossed and out of control. This dramatic picture resulted.

The picture was used in the Times and became a topic of conversation among the skiers. However, non-skiers assumed it was a planned stunt and dismissed it lightly. No skier, however great, finds himself in this position in midair and recovers.

1/1000 SEC. F 8 120 TRI X FILM
G FILTER 80 MM JENA LENS
PENTACON SIX CAMERA

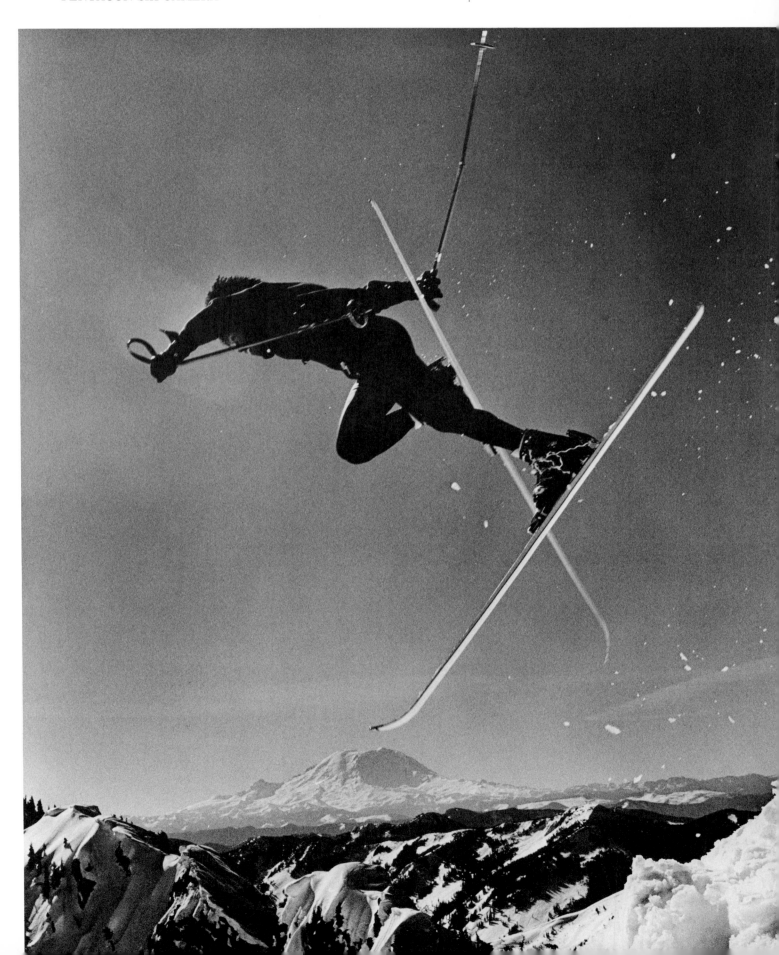

COLOR PHOTOGRAPHY

Color film and the 35 mm Single Lens Reflex cameras are responsible for the current status and popularity of photography. It is the so-called nonprofessionals working in color who are now making the most pleasing pictures. Many professionals are too concerned with what will sell, what is currently fashionable, and what brings awards.

Color pictures used to distort nature or to imitate paintings are a discredit to the intelligence and taste of the photographer.

A photographer using a simple, straight photographic procedure can, with 35 mm color slide film, record nature with an accuracy never before possible. Skilled photographers, both professional and nonprofessional, using this format can compete in any area of photography.

Kodachrome, an almost grainless color film, permits mural size blow-ups from a 35 mm slide. It is not available for the larger cameras.

High speed color photography depicting sports action is best shot with the 35 mm SLR. The quality and great assortment of lenses, along with several choices of high speed color films, again provide a big advantage for the 35 mm SLR. Mobility and rapid shooting are also plus factors.

Color photography with the 35 mm SLR is simplicity itself. Do not complicate your SLR with needless equipment. I do not use any filters for color photography. It has been my observation that they actually alter nature's colors.

I often see 35 mm color slides made by beginners which are of such beauty and interest that any professional would be proud to have taken them. The 35 mm SLR brought to photography highly artistic people, especially women, who would be discouraged by the technical commitment required in using larger cameras.

In color, as in black and white photography, subject matter is all important. Again look to nature and the noble works of man for pleasing and lasting subject matter.

Nature provides the northwest color photographer not only never-ending scenic beauty, but great dramatic projections. The storms, the weather changes, man's interesting vocations and avocations typical of the region are among the many great subjects indigenous to this area. Many, many, small subtleties also abound in our corner of the country. Look at the mists rising from Lake Washington pinked by the rising sun over the Cascade range, the variation of delicate hues in the rain forest, the fragile wild flowers against the peaks.

Color film and the 35 mm SLR seemingly were created precisely for and meant especially for the Northwest.

INDIAN BASKET WEAVER

A great subject like this Indian lady on the Quinault reservation at Taholah, Washington, is worth all the effort, skill, and knowledge the photographer may possess.

The color not only portrays the character of the subject, it reveals the true coloring of the subject and the surroundings, the texture and nature of the material used in the weaving. As an educational medium, color far surpasses black and white photography. I doubt that there has ever been anything as effective as color film in the educational field.

I feel this picture graphically illustrates the strength and excitement of straight photography when properly employed on a worthwhile subject.

Although I dislike the use of a tripod except for time exposures, I set up a tripod for this one.

1/25 SEC. F 22 135 MM OPTAR LENS
4 × 5 SPEED GRAPHIC CAMERA 3 NUMBER FIVE FLASHBULBS
TYPE B EKTACHROME FILM ASA 25

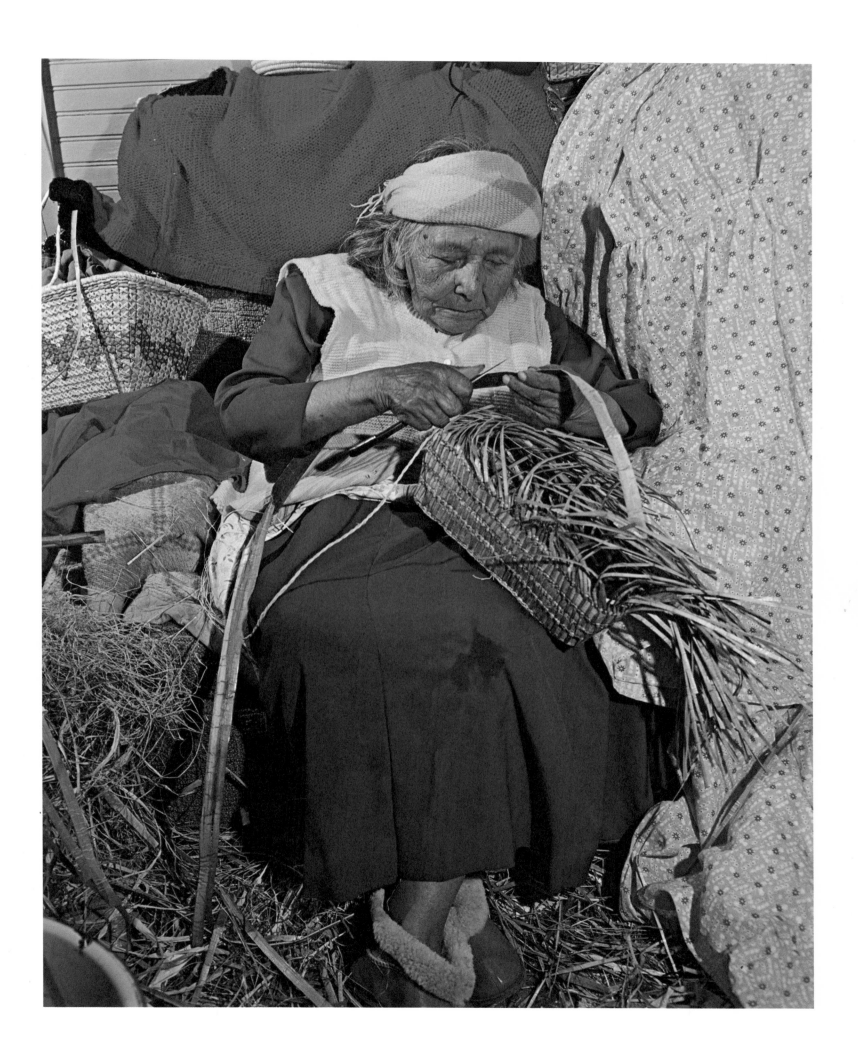

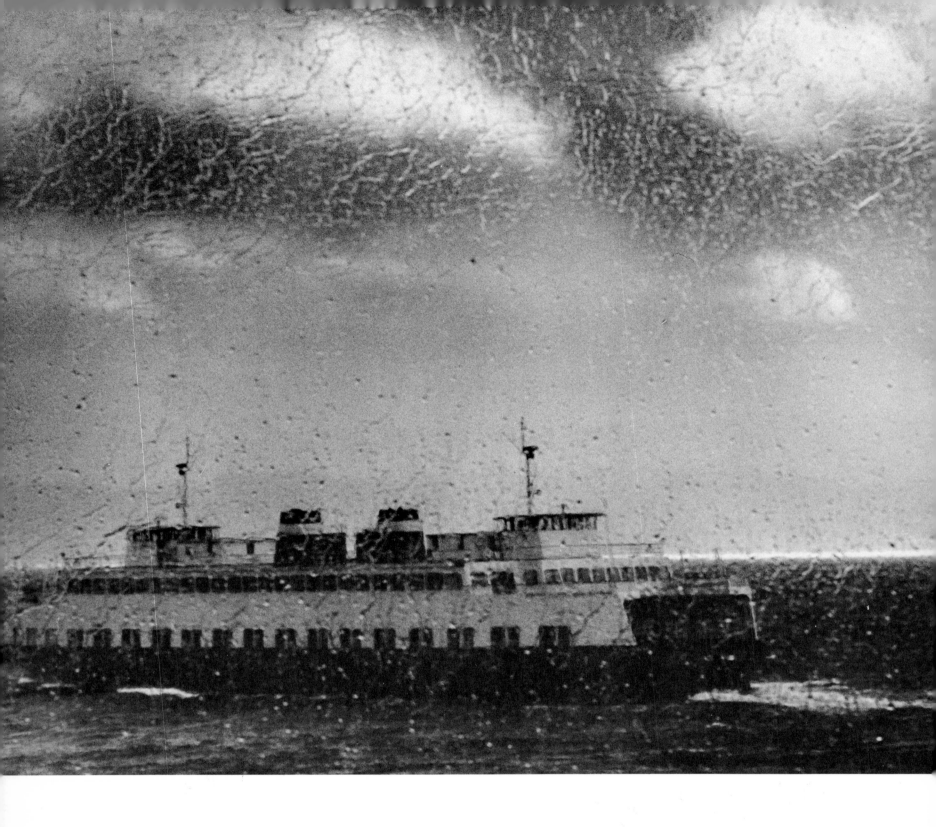

On this November crossing, there was a wind-driven rain with patches of blue sky and white clouds in the distance. The windows were rain streaked and another ferry was approaching.

I never ride a ferry without a camera in hand. Always there are picture opportunities on a ferry trip. On this occasion I noticed the approaching ferry boat in time to replace the normal 80 mm lens with a 250 mm telephoto lens, pre-judge the focus, compose the picture, and hope the ferry would remain on course. There would be time for only one exposure.

1/250 SEC. F11 120 TRI X FILM
G FILTER 250 MM ZEISS LENS
HASSELBLAD CAMERA

Early one December morning there was heavy new snow on the Olympics. It was very cold and the atmosphere was unusually clear.

I used infrared film to place extreme emphasis on the Pacific Science Center and the Olympic Mountains.

I recommend only occasional and very selective use of infrared film.

1/2 SEC. F 22
A FILTER (RED)
4 × 5 SPEED GRAPHIC CAMERA

INFRARED FILM
360 MM TELE XENAR LENS

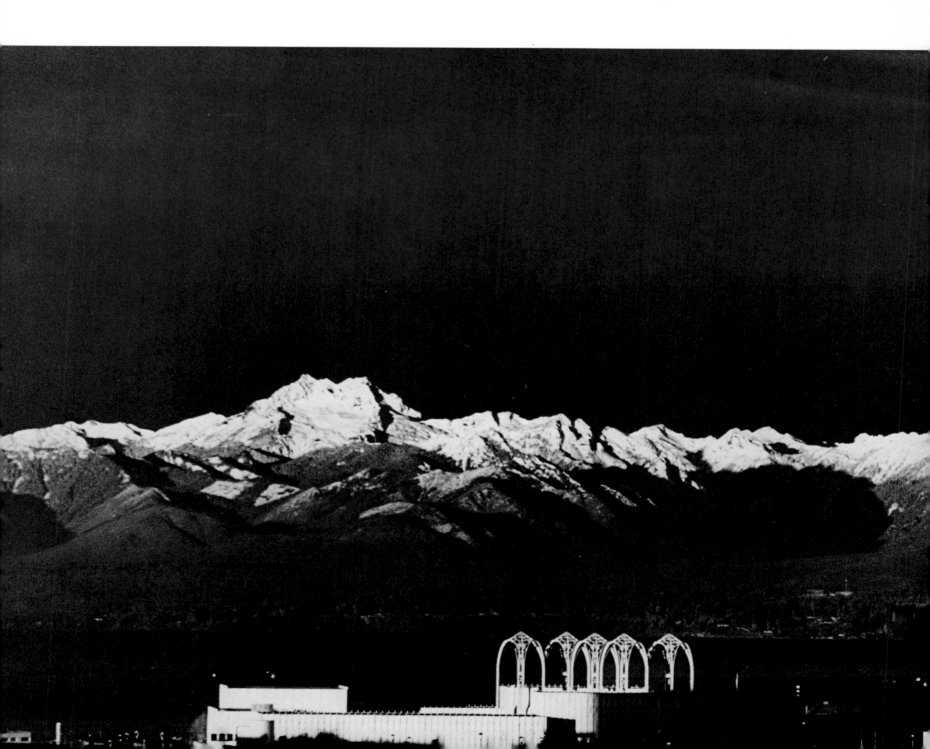

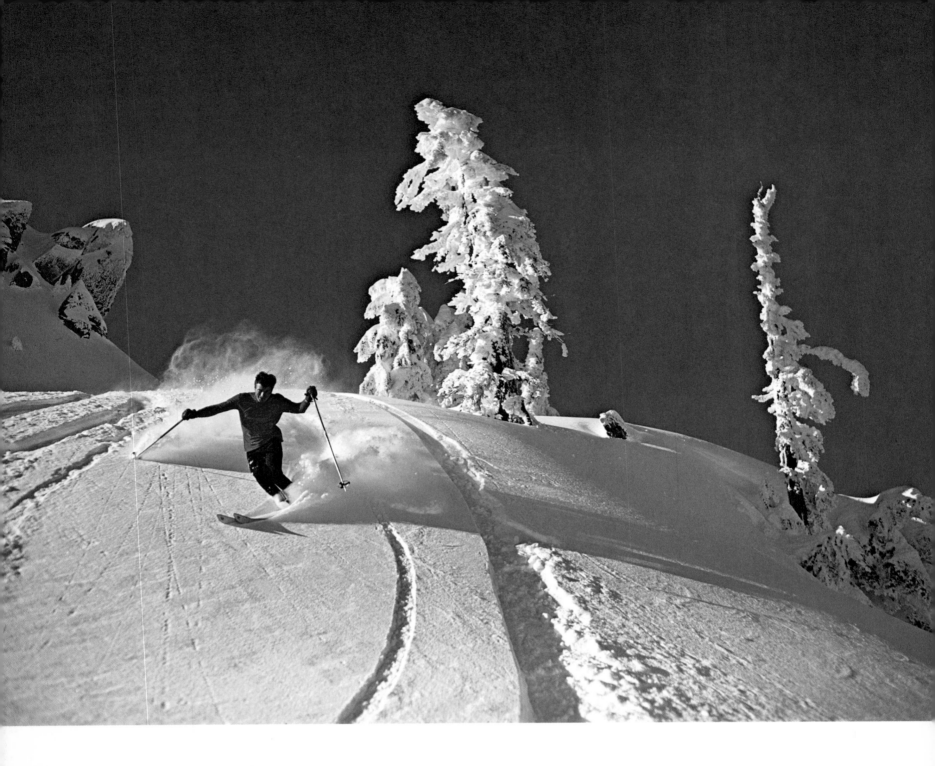

SKI ACTION

I work with New York picture agencies who still insist on 4 × 5 transparencies for their calendar art. For this reason, I am often seen using the 4 × 5 Speed Graphic for ski action. The compact and versatile 35 mm is the ideal camera for the ski slopes. In this picture, however, a large camera was more effective. The 4 × 5 film size allowed considerable background with a much larger figure than would have been possible with the 35 mm format.

Regardless of the camera used, here is a scene of universal appeal, a most beautiful mountain scene with a skier worthy of the setting. A poorly equipped skier of awkward technique would have been inappropriate here.

Shooting in late afternoon gives the long shadows a most pleasing, blueish cast.

To freeze close-up ski action, a shutter speed of 1/1000 of a second is necessary.

1/1000 SEC. F 5.6 EKTACHROME FILM ASA 50
4 × 5 SPEED GRAPHIC CAMERA 135 MM OPTAR LENS

Normal exposure for this film and these light conditions was 1/200 second at F 11. The ASA film speed of 50 was increased to an ASA of 200 by push development. Increasing the speed of certain color films by as much as three stops is possible with push development.

SEA GULLS

Conducting a KVI PAY'N SAVE photo seminar aboard the Princess Marguerite, I assigned 800 camera enthusiasts and myself to photograph the sea gulls. Sea gulls in flight are always a worthy subject and keeping a sea gull in the viewfinder is excellent eye training.

This is my favorite color picture of 1974. It has the clean, free, breezy feel of an ocean voyage. It was not an easy shot to get but, most of all, it proves the greatness of color film in rendering the subtle and delicate colorings in the water which often go unnoticed by the eye.

I feel certain I could not have made this picture with any camera other than the 35 mm SLR. A shutter speed of 1/500 of a second or faster is necessary when photographing birds in motion.

1/1000 SEC. F 5.6 GAF 100 ASA FILM
NIKKORMAT CAMERA 105 MM NIKKOR LENS

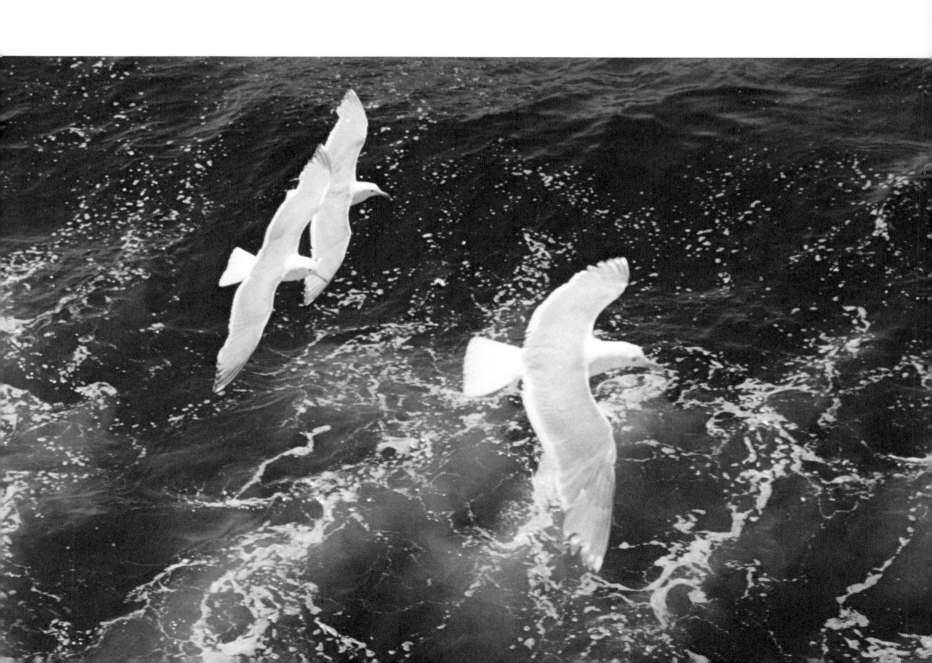

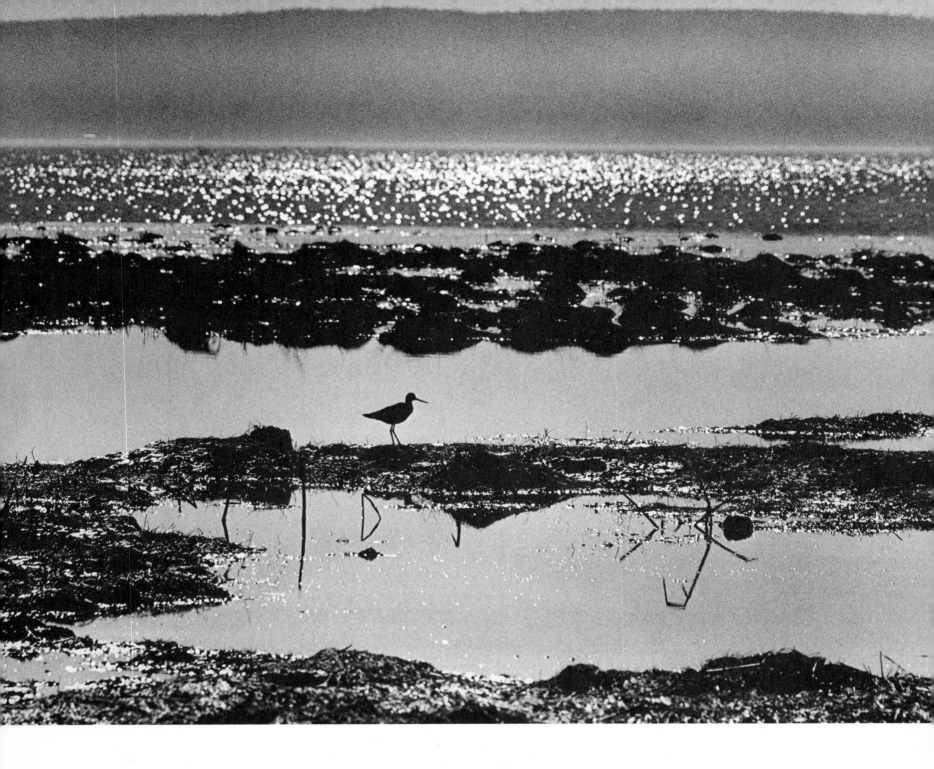

On this beautiful winter morning I went to the Skagit Flats expecting to photograph the majestic trumpeter swans that winter in the area. Not finding the swans, I sought the snow geese but had no luck. Instead, a plover seeking breakfast in the tide pools produced this quiet, pleasing little scene which has become a consistent prize winner.

The soft, early morning backlight, diffused by mist rising over the water, gives the overall low-key effect. The shallow depth of field also is in keeping with the mood, as are texture and tonal qualities.

1/500 SEC. F 8 120 TRI X FILM
G FILTER 500 MM ZEISS TESSAR LENS
HASSELBLAD CAMERA

These men were netting smelt in July at Kalaloch on the Washington coast. The picture is given added interest by the children romping in the creamy surf and the sea gull keeping just out of reach of it.

1/500 SEC. F 16 120 TRI X FILM
G FILTER 80 MM ZEISS LENS
HASSELBLAD CAMERA

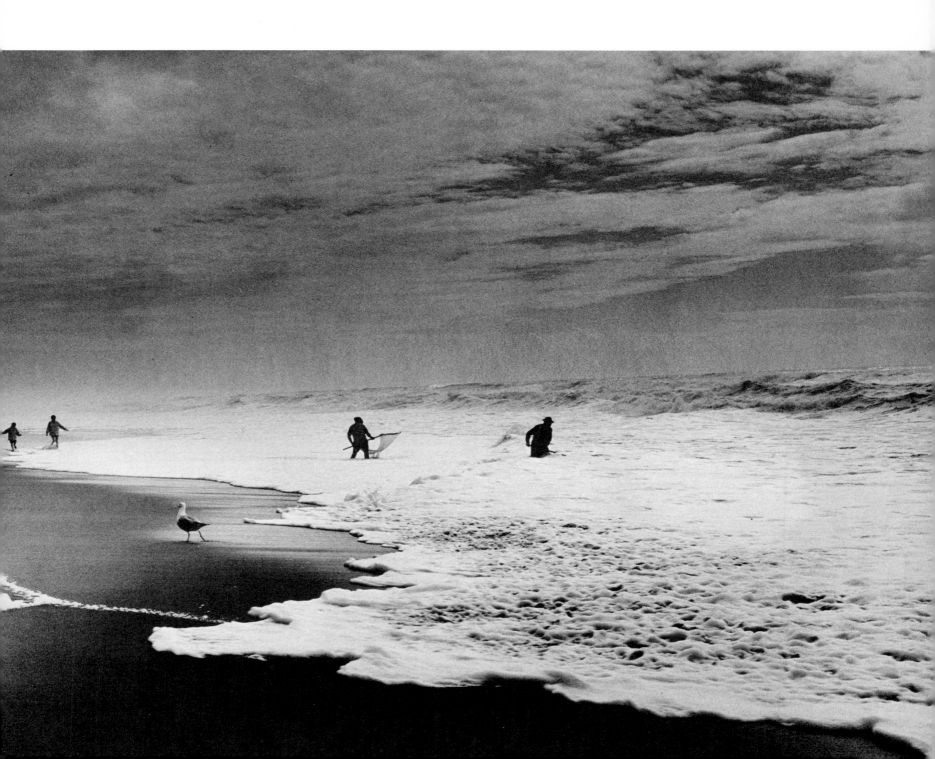

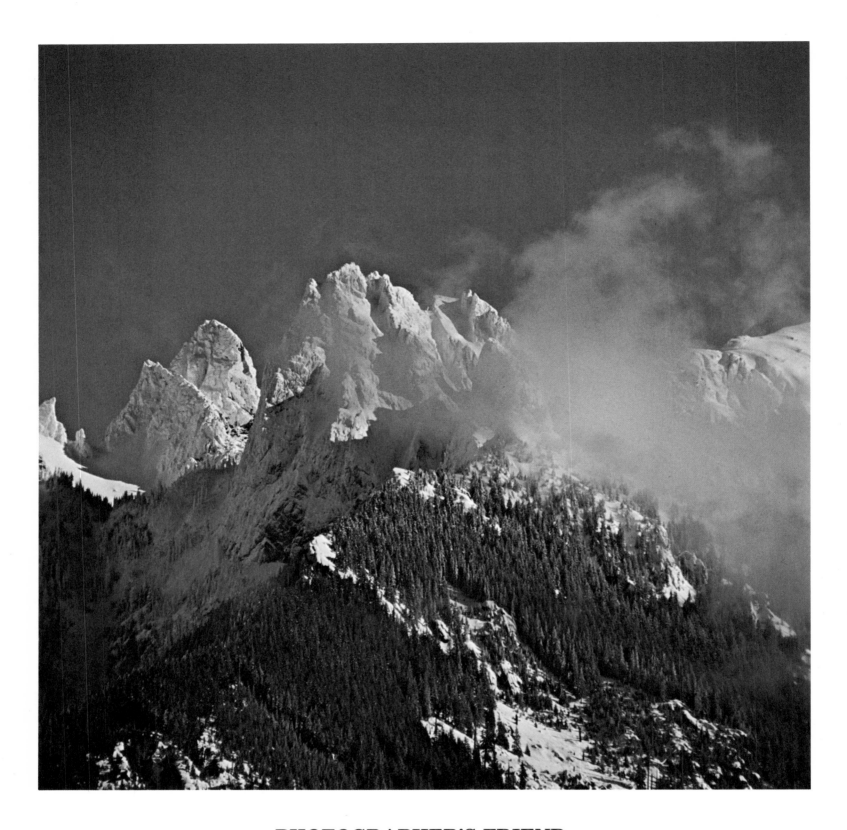

PHOTOGRAPHER'S FRIEND

Mountains are a northwest photographer's best friend. How is it possible to take a poor picture of a mountain?

More color film is expended on mountains than any other northwest subject. Most mountain pictures are taken on beautiful days against a cloudless blue sky. There is nothing wrong with that. However, whenever there is a dramatic change in the weather, I keep an eye on the mountains. It is over the mountains that the most spectacular projections occur. Mountains and clouds team up for nature's greatest visual presentations.

Driving over the Stevens Pass Highway the morning after an early winter snow, I began noticing breaks in the overcast. Suddenly near the town of Index, the peaks stood out with unusual clarity. Swirling, misty clouds added considerable aesthetic interest. I was able to make this picture from the highway with a long telephoto lens.

1/500 SEC. F 16 500 MM ZEISS LENS
HASSELBLAD CAMERA HAND HELD
GAF FILM ASA 200

SUNSET

The reflection of a red winter sunset in the Snohomish River produced this unusual picture.

When on exhibit, this picture always becomes a topic of conversation. Many viewers assume it is effected by manipulation in printing. Actually, it is pure, straight color photography.

The camera was hand held, but I braced myself by leaning against a tree in order to hold the camera steady. Hand holding a long telephoto at less than 1/125 of a second is not advised.

1/60 SEC. F 8 GAF FILM ASA 200
HASSELBLAD CAMERA 250 MM ZEISS SONNAR LENS

High, midsummer sun backlights the participants in a Hobie Cat race on Shilshole Bay. A trace of the Olympic Mountains in the background locates the picture.

Low angle shooting from a small powerboat with a medium telephoto lens against the light is my formula for sailboat photography.

The feel of action, wind, water, and stress would be lost if this picture were shot with the sun.

1/1000 SEC. F 11 120 TRI X FILM
G FILTER 180 MM JENA LENS
PENTACON SIX CAMERA

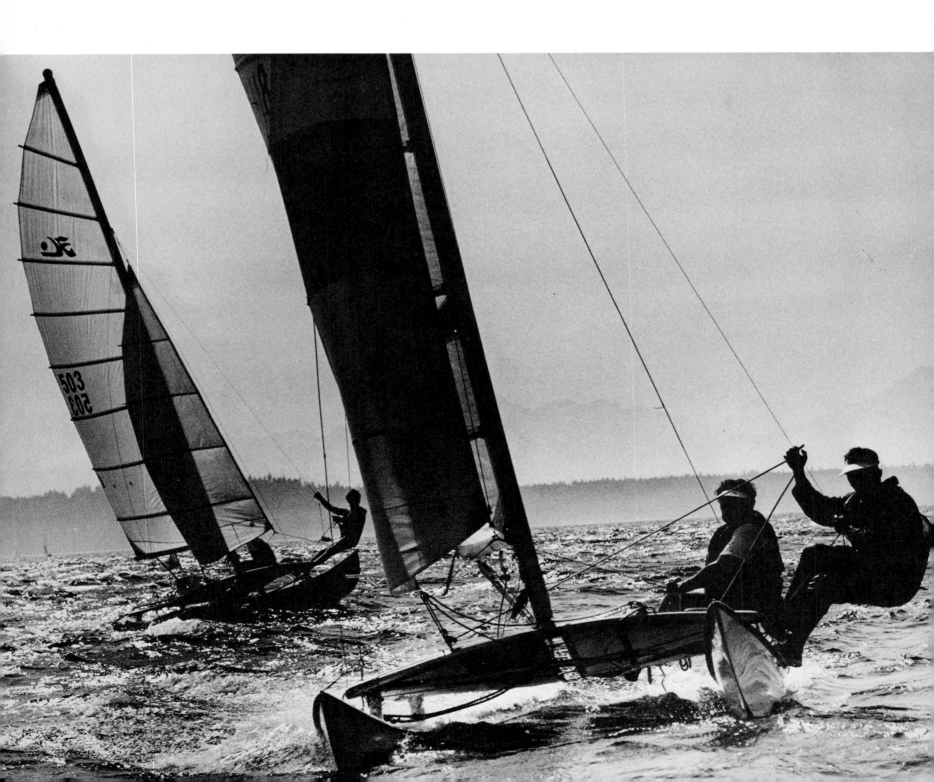

NIGHT PHOTOGRAPHY

With the new, super accurate exposure meters, night photography is as simple as daylight shooting. I was assigned to make this shot of the Evergreen Point Bridge when it was first completed.

I waited for a still, windless night because I wanted to use a long telephoto lens for compression impact. I wanted maximum light reflection in the water. I knew the exposure would be a long one. To achieve a reasonable depth of field with the 360 mm telephoto lens, I planned to close the aperture to F 22. The exposure meter called for an exposure of twenty-five minutes at F 32. I felt the meter was reading high, influenced by the bright overhead lights. The exposure I decided to use was twenty-five minutes at F 22. This gave a considerable overexposure in the overhead lights, but recorded the color in the water very well.

In spite of the precise accuracy of the modern exposure meter, when working with bright lights and black water, or bright city lights and dark buildings, an increase in the meter reading is necessary. This is a judgment factor perfected by experience.

My rule of thumb in night photography: a night scene is often made warm and friendly by overexposure. Even slight underexposure in a night scene makes it cold and most unpleasing.

25 MIN. F 22
4 × 5 SPEED GRAPHIC CAMERA

EKTACHROME FILM ASA 25
360 MM TELE XENAR LENS

MOST PHOTOGRAPHED SUBJECT

Surely the photographer working only in black and white must experience a great frustration each autumn. Autumn provides never ending opportunities and excitement for the color photographer.

Here in the Northwest, we not only have the color and activities of autumn, but we have the majestic mountain peaks to use as a backdrop for the color.

This scene of Mt. Shuksan is perhaps the most photographed subject in the Northwest. The wild huckleberry bushes which create the crimson carpet of color in the foreground reach their color peak during the first week of October. Tiny Picture Lake adds a further visual bonus.

In this setting, nature presents to the photographer all the elements for the perfect landscape composition, color-coordinated and flawlessly arranged. The scene requires no hiking. The best angles are all from a paved highway and the normal lens gives the best perspective. I have seen beautiful color prints of this scene taken with the most inexpensive 35 mm cameras, as well as with large professional-size cameras.

To record this scene successfully, the photographer has only to be there on a bright, sunny autumn day.

1/25 SEC. F 22
NO FILTER
4 × 5 SPEED GRAPHIC CAMERA

EKTACHROME FILM ASA 50
135 MM OPTAR LENS (NORMAL)

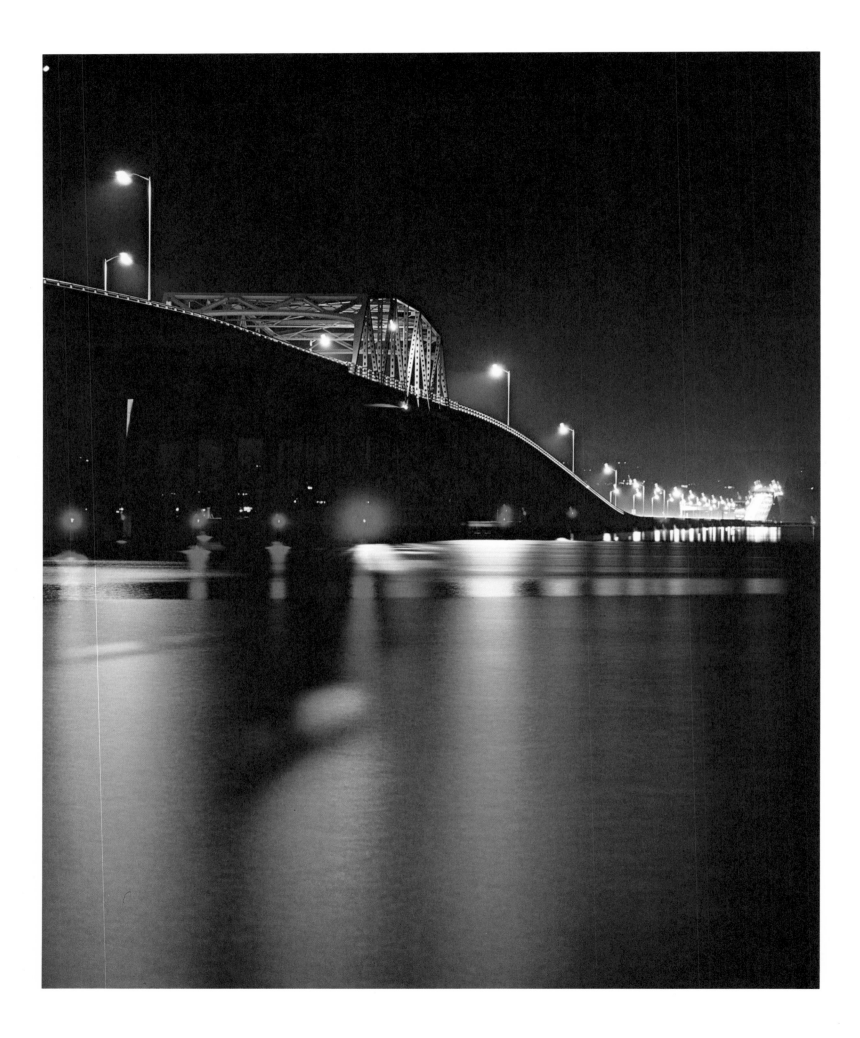

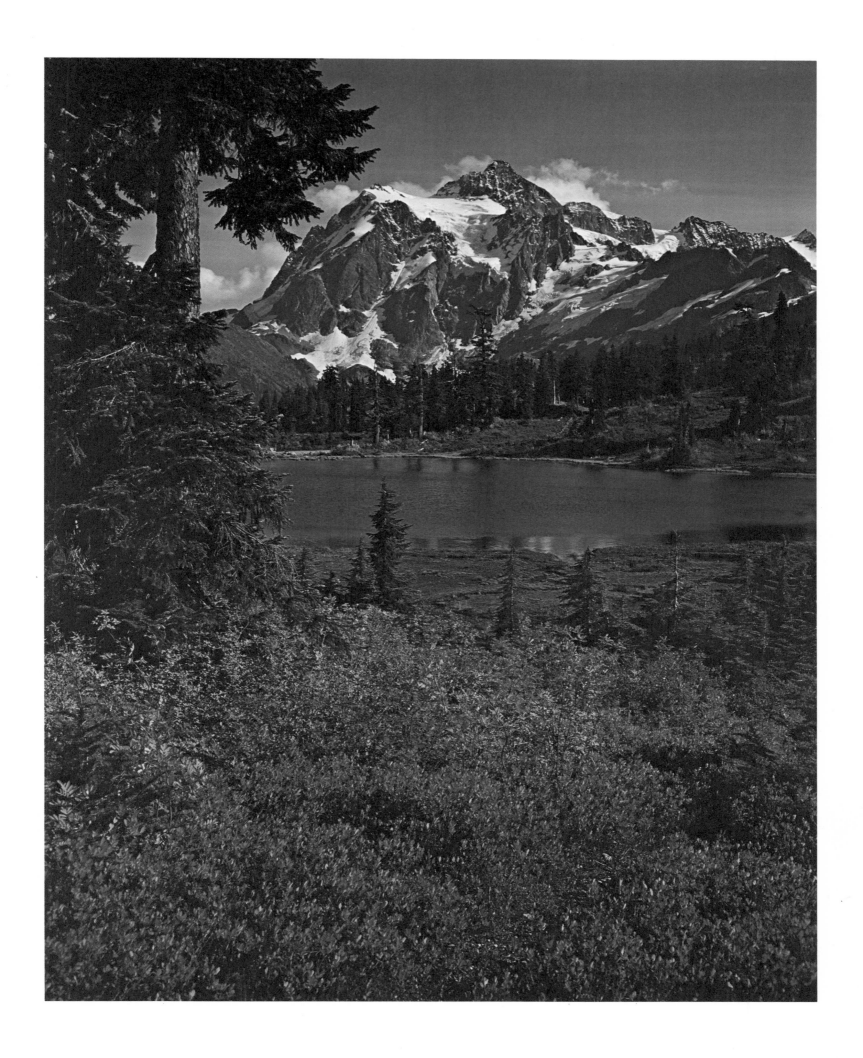

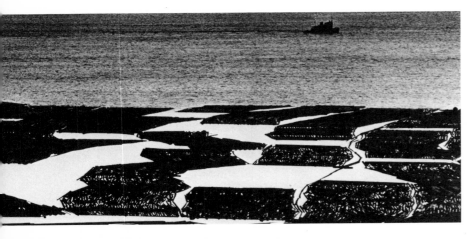

Generally, editing should be done in the viewfinder. However certain subjects are of such extreme vertical or horizontal format that cropping in the enlarger is necessary.

This log boom, photographed at dusk on Lake Washington, is transformed into a striking abstract design by cropping.

A hillside fence is further elongated by severe cropping.

LOG BOOM
1/60 SEC. F 5.6
NIKON CAMERA
TRI X FILM
300 MM NIKKOR LENS
HAND HELD

FENCE
1/250 SEC. F 16
HASSELBLAD CAMERA
120 TRI X FILM
500 MM ZEISS TESSAR LENS
HAND HELD

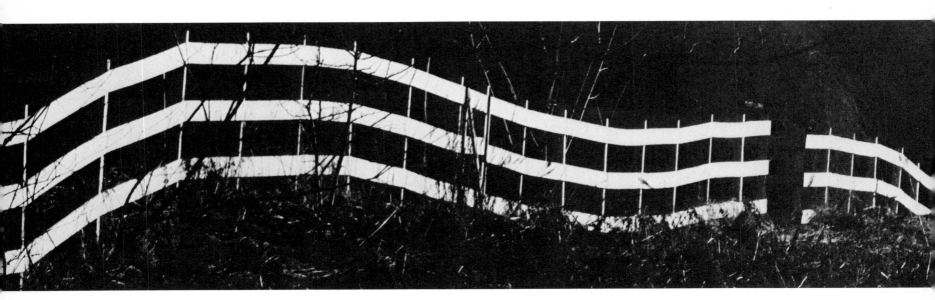

PICTURES ON FOLLOWING PAGES

THE RAIN FOREST

The Hoh River forest in the autumn rain is fast becoming my most popular photograph. It was taken in November of 1974 on a gloomy day in a downpour of steady rain.

It wasn't planned that way. I left Seattle in overcast weather with diffused sunshine—ideal conditions for shooting the contrasty, heavily shadowed rain forest. Bright sun produces contrasts in the rain forest beyond the tolerance range of color film or black and white film.

The delicate, graceful green moss is washed out by extreme overexposure or completely lost in the shadows. The exposure meter called for an overall exposure of eight seconds at F 11.

Because the hanging moss soaks up light rather than reflecting light, I chose to double the exposure. This worked very well in keeping the moss green and gave the overall scene a more pleasant effect. Color film combined with long and generous exposure works remarkably well in dark forest on overcast days.

I used a normal lens but would have preferred a wide-angle lens. However, the extremely shallow lens hood required for the wide-angle lens gives little if any protection to the lens from rain. With the deeper lens hood of the normal lens and with the help of jackets, reflector boards and Kleenex, I was able to get in almost thirty minutes of shooting time.

16 SEC. F 11 EKTACHROME FILM ASA 50
4 × 5 SPEED GRAPHIC 135 MM OPTAR LENS

APPLE BLOSSOMS AND RED BARN

In the northwest, because of the grandeur of our scenery, most photographers overlook a great many lesser, but extremely good, subjects.

I cut my photographic teeth in Connecticut, a state of very small dimensions with no mountain grandeur whatsoever. This has worked to my advantage here. My pictures of the lesser scenes impart a change of pace to my work.

I have always and will continue to comb the rural areas for my most satisfying landscapes. It was on such a self-given assignment that I came upon this rural classic: a beautiful spring day, apple blossoms, and an old red barn.

Here again, as I do whenever possible without weakening the aesthetics of the composition, I use a northwest label. This gives it personal identity to those of us who are so proud of our area. In this instance, the Cascades in the background establish it as our own.

1/10 SEC. F 32 EKTACHROME FILM ASA 50
4 × 5 SPEED GRAPHIC CAMERA 360 MM TELE XENAR LENS
TRIPOD

It was necessary to shoot at F 32 for depth of field. Slow shutter speeds and telephoto lenses require a tripod for sharpness.

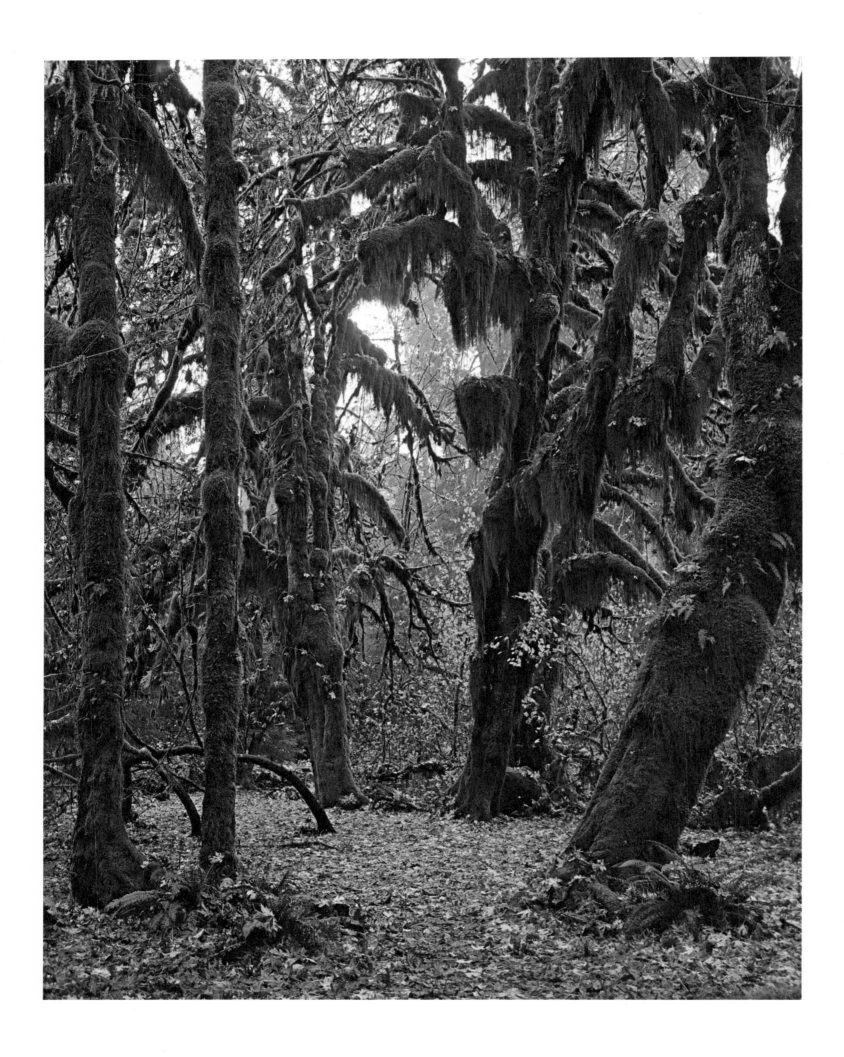

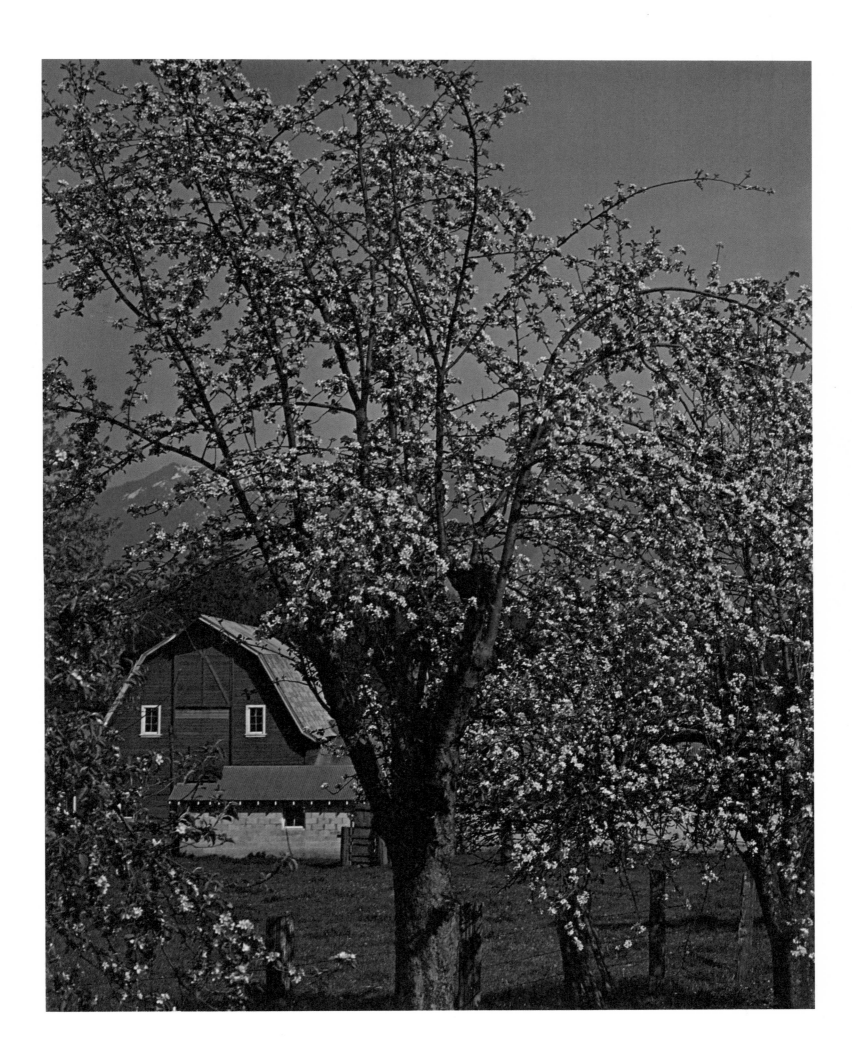

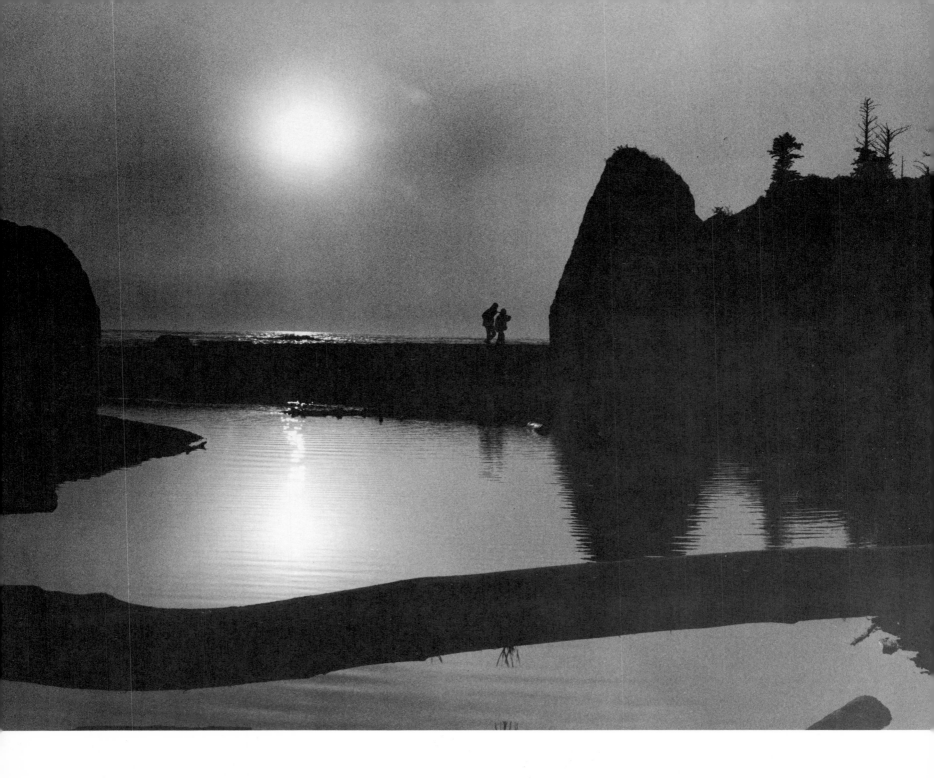

Low light levels often produce the best pictures. I was looking through the viewfinder at a moonrise and debating if the scene was worth the time and effort to set up a tripod, when the hikers appeared. With the hikers, the scene immediately demanded I attempt to record it, although I felt certain it would produce an unprintable negative. While the negative was thin, it was printable on Number Five contrast paper.

1/25 SEC. F 4 120 TRI X FILM
NO FILTER 80 MM ZEISS LENS
HASSELBLAD CAMERA

While waiting for a sailboat to move into the strip of backlighted water, two joggers appeared in the viewfinder, producing a much more striking picture than another sailboat silhouette.

1/1000 SEC. F 22	120 TRI X FILM
G FILTER	300 MM JENA LENS
PENTACON SIX CAMERA	

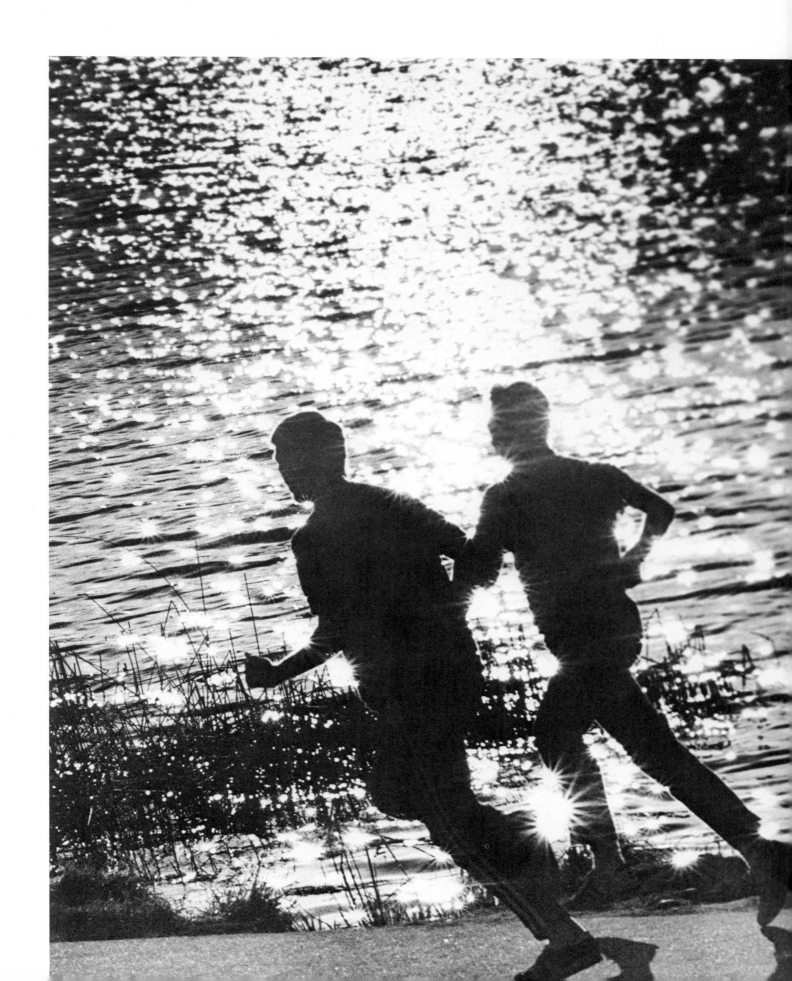

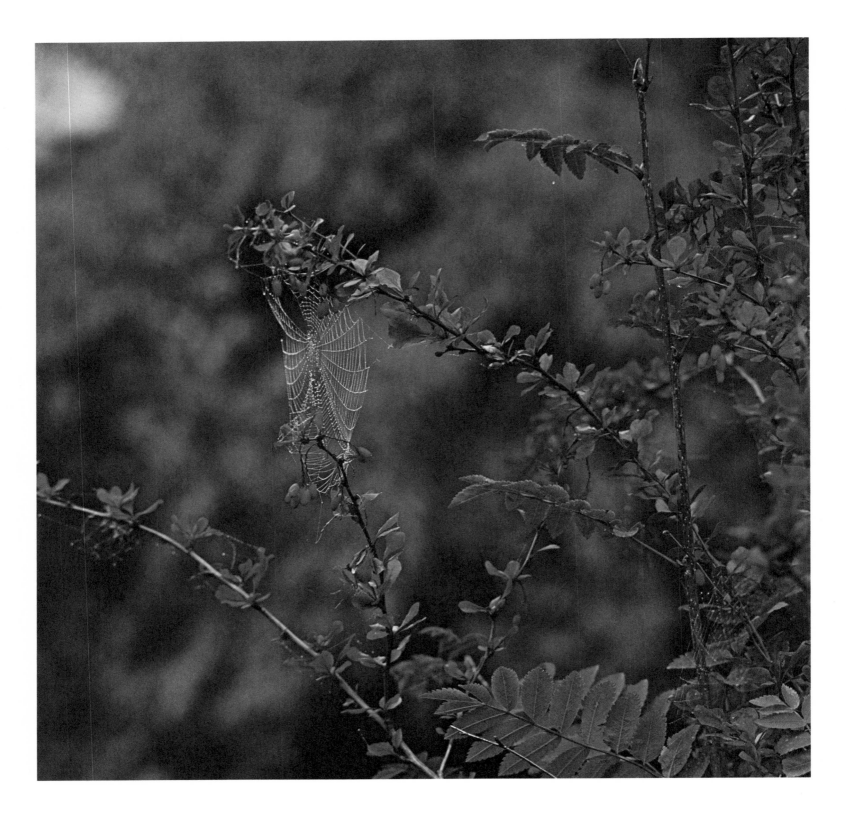

SPIDER WEB

High among nature's most beautiful photographic subjects are the cobwebs of autumn.

On a cold morning when the delicate threads are beaded, pencil thick with dew, there is no subject more fascinating anywhere.

Cobwebs must only be shot against the sun. Without direct backlight the cobwebs are lost in the background. I use only the long telephotos for cobweb shooting. The telephoto's narrow angle of view makes it possible to shield the sun from striking the lens. It brings close-up the choice webs in the higher shrubs and its shallow depth of field allows the background to remain out of focus.

The cobweb shown was made on a cold, still morning just as the sun broke through the mists.

1/100 SEC. F 8 360 MM TELE XENAR LENS
4 × 5 SPEED GRAPHIC CAMERA
EKTACHROME PROFESSIONAL
 FILM ASA 50

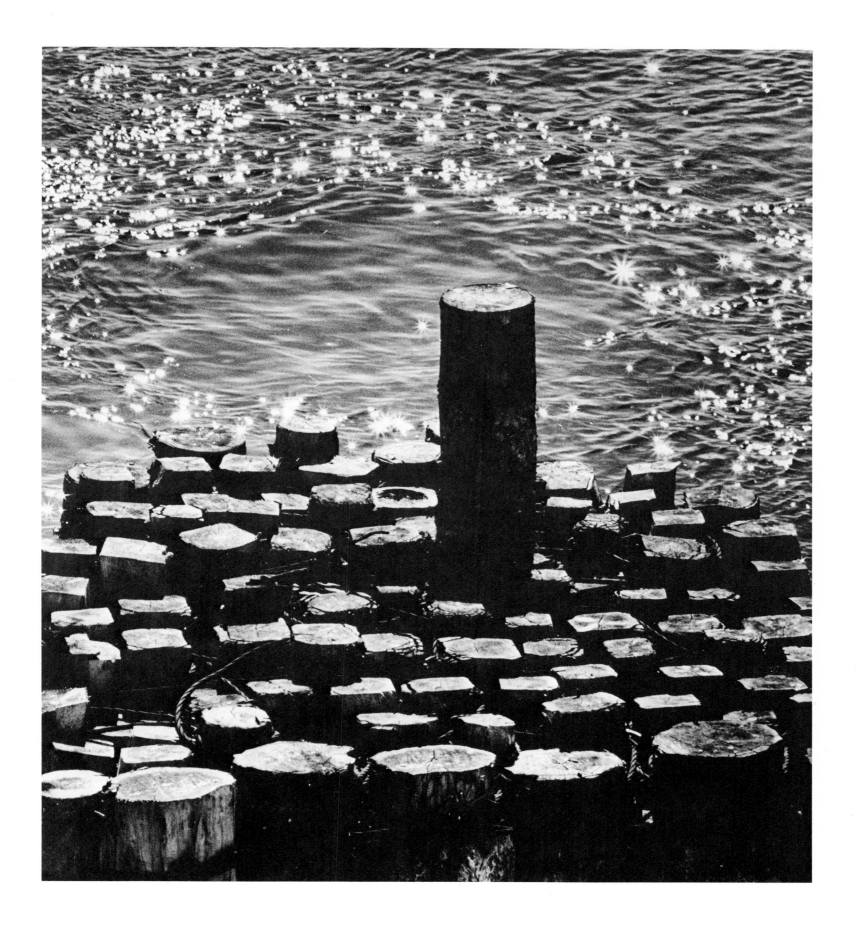

 The ferry dock piling at Winslow was shot from the deck of a departing ferry. The picture is interesting from a standpoint of lighting, texture, design, and composition.

 It graphically illustrates the effectiveness of photographic artistry and craftsmanship.

1/250 SEC. F 22 120 TRI X FILM
G FILTER 250 MM ZEISS LENS
HASSELBLAD CAMERA

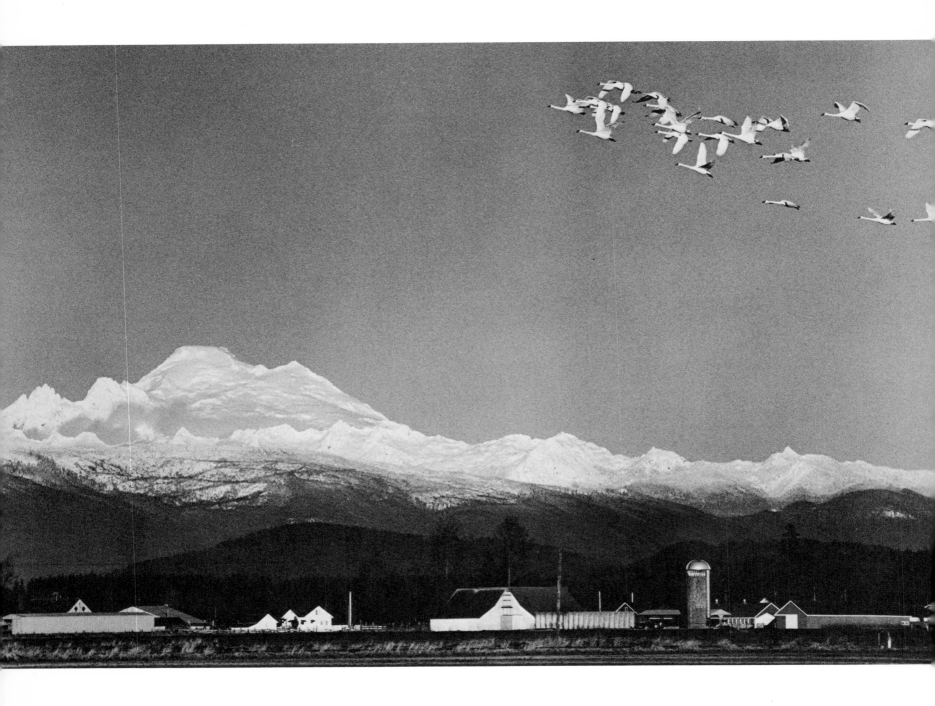

From time to time, every photographer commits himself totally to one subject. In the winter of 1973, I found myself involved in this manner with the migrating trumpeter and whistling swans that spend a short winter in the Skagit Valley.

I am by no means an expert on wildlife but I believe there is nothing in nature that begins to approach the magnificence of these birds in flight.

During migration, swans become extremely wary. Seldom can a photographer approach closer than 100 yards.

Before you can photograph the swans, however, you must find them. The Skagit Valley is a vast area and the swans day-to-day whereabouts are unpredictable. I would first look for the whistling swans in the Fir Island area; then I would seek the trumpeters ten miles further north in the Clear Lake area. On days when I found neither the whistlers nor the trumpeters, I would photograph the snow geese and other scenic, seasonal activities.

When I did find them in the fields and they became airborne at my approach, seldom did they fly in the direction I wished.

Long telephoto lenses, hand held, high shutter speeds, high speed films, and much perserverance is my formula in any similar project involving wildlife.

This picture of whistling swans over the Skagit Valley had very high reader response when it ran in the Times. The numerous letters, phone calls, and print orders resulted more because of Mt. Baker than the swans. A spectacular northwest landmark in the background helps any picture.

1/500 SEC. F 16 120 TRI X FILM
G FILTER 250 MM ZEISS SONNAR LENS
HASSELBLAD CAMERA

Taken on a rainy, overcast day, this picture of trumpeter swans over Clear Lake has a strong feeling of mood and motion.

Photographically, it is a much better picture but because there is no Northwest landmark in the background, it had only normal reader response.

1/500 SEC. F 8 120 TRI X FILM
G FILTER 500 MM ZEISS TESSAR LENS
HASSELBLAD CAMERA

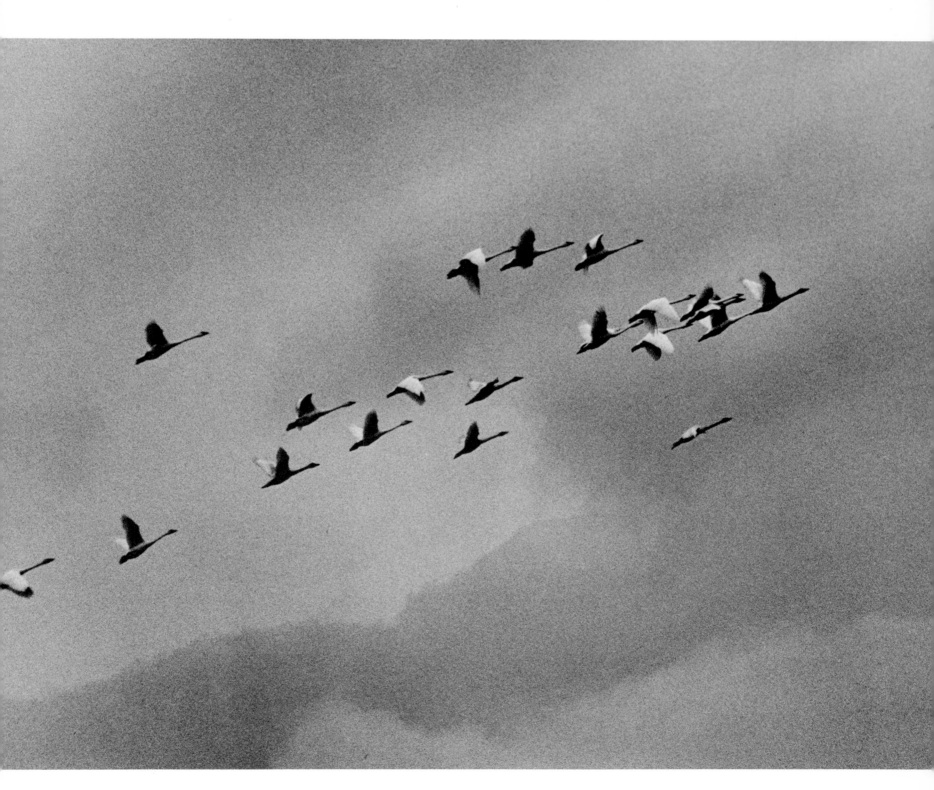

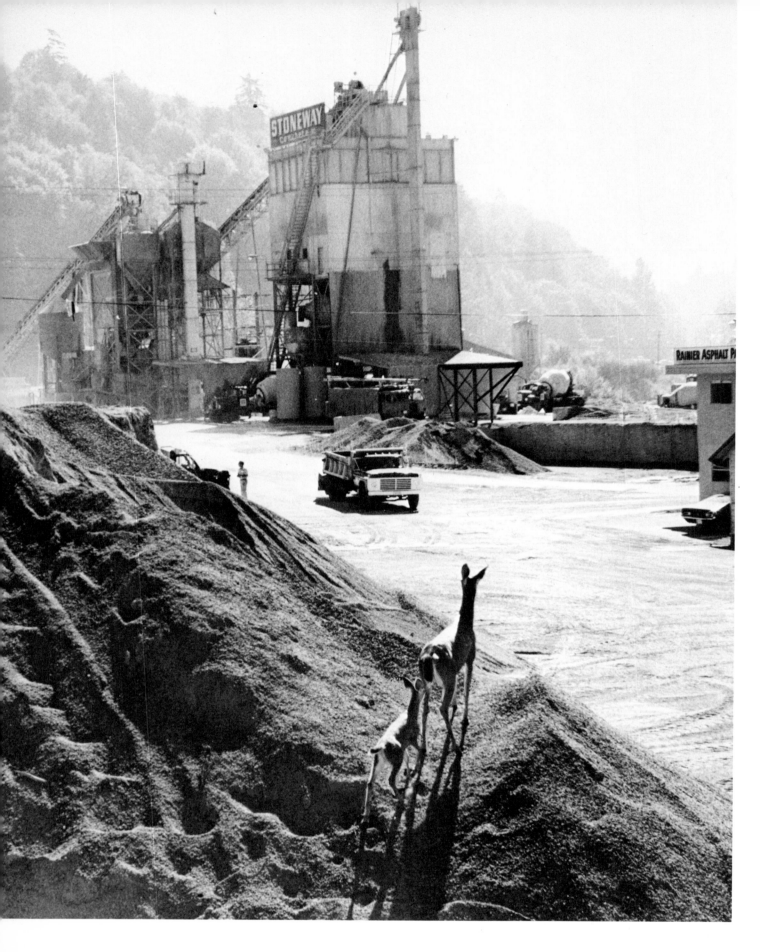

In August of 1971, during the very height of the ecology concern, I was delivering pictures for an exhibit in Renton when my attention was called to a doe and her fawn crossing the busy highway.

The two deer continued on into the very center of a bustling industrial plant, posing briefly on a mound of aggregate.

The Times used it front page. The Associated Press sent it around the world and caption writers everywhere had a field day. Many front page tear sheets were sent to me. Here are two typical captions.

"Doe and fawn take a cautious look at man."

"And this, my child, is civilized man."

1/500 SEC. F 11 120 TRI X FILM
G FILTER 250 MM ZEISS SONNAR LENS
HASSELBLAD CAMERA

This was a routine speculative assignment of the annual Halloween pumpkin harvest. It was a pleasant, colorful assignment but I expected nothing to excite the picture desk.

I was shooting away at the moving trailer load of pumpkins when, out of a bordering cornfield, a black cat jumped on the load of pumpkins. I was able to make several exposures before the cat was back in the cornfield hunting mice again.

I converted the color to black and white. The *Seattle Times* ran it on page one. The Associated Press moved it on the wire and it was featured as the Halloween picture in newspapers throughout the nation.

It was just plain good luck that produced this prize picture.

1/250 SEC. F 11 HIGH SPEED EKTACHROME FILM
HASSELBLAD CAMERA 50 MM DISTAGON LENS

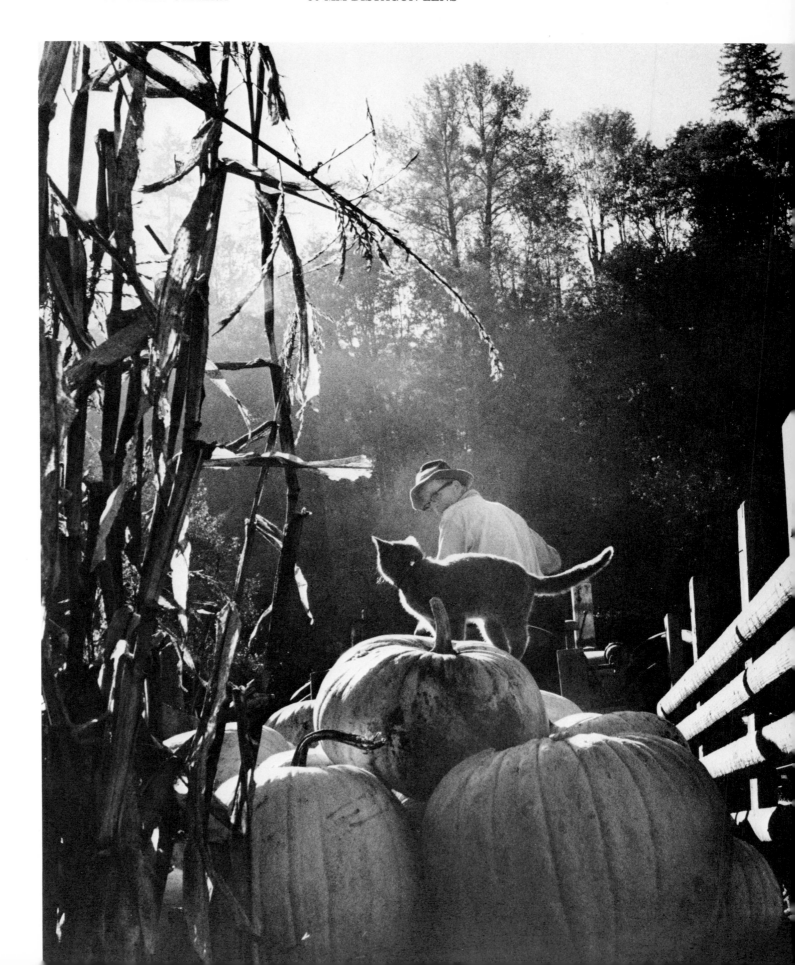

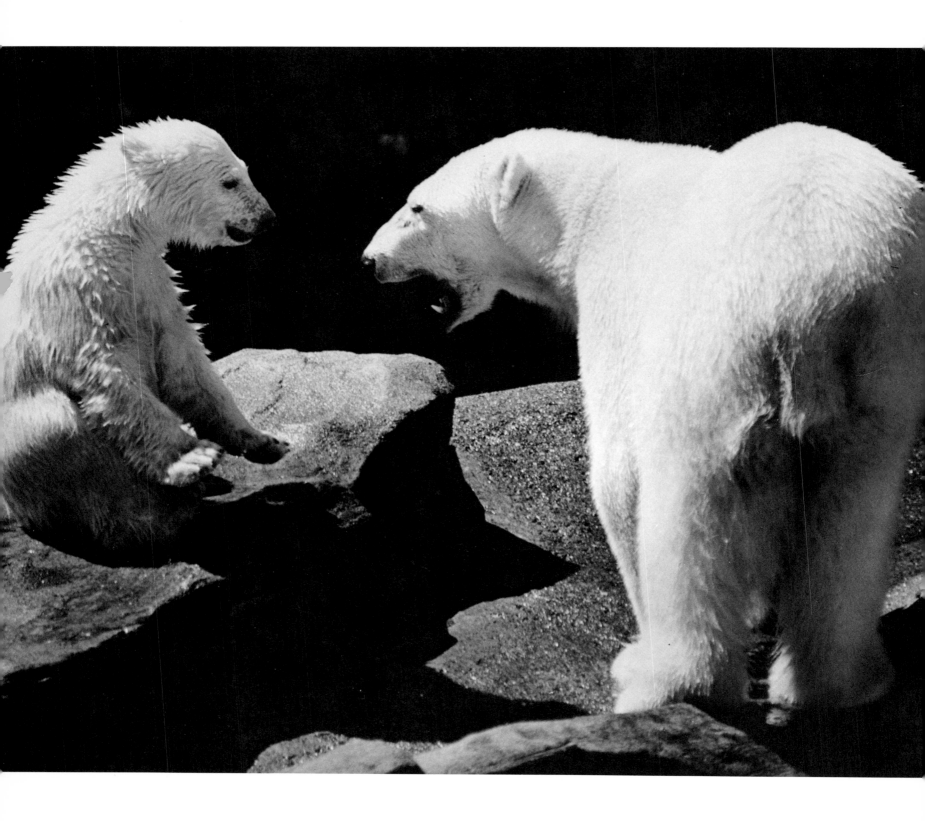

Here a mother polar bear is giving her cub a scolding. Many readers chuckled over this one. Whenever a photographer comes upon a situation of uncontrived humor, he has the formula for a successful picture.

1/250 SEC. F 11 120 TRI X FILM
HASSELBLAD CAMERA 250 MM ZEISS SONNAR LENS

Driving on Bainbridge Island on a quiet, spring morning, I was intrigued by the angle and perspective of this scene.

The click of the shutter apparently annoyed the horse and prompted this expression of disdain. I call this picture, "Photographer, go home!"

1/250 SEC. F 16
G FILTER
HASSELBLAD CAMERA

120 TRI X FILM
250 MM ZEISS SONNAR LENS

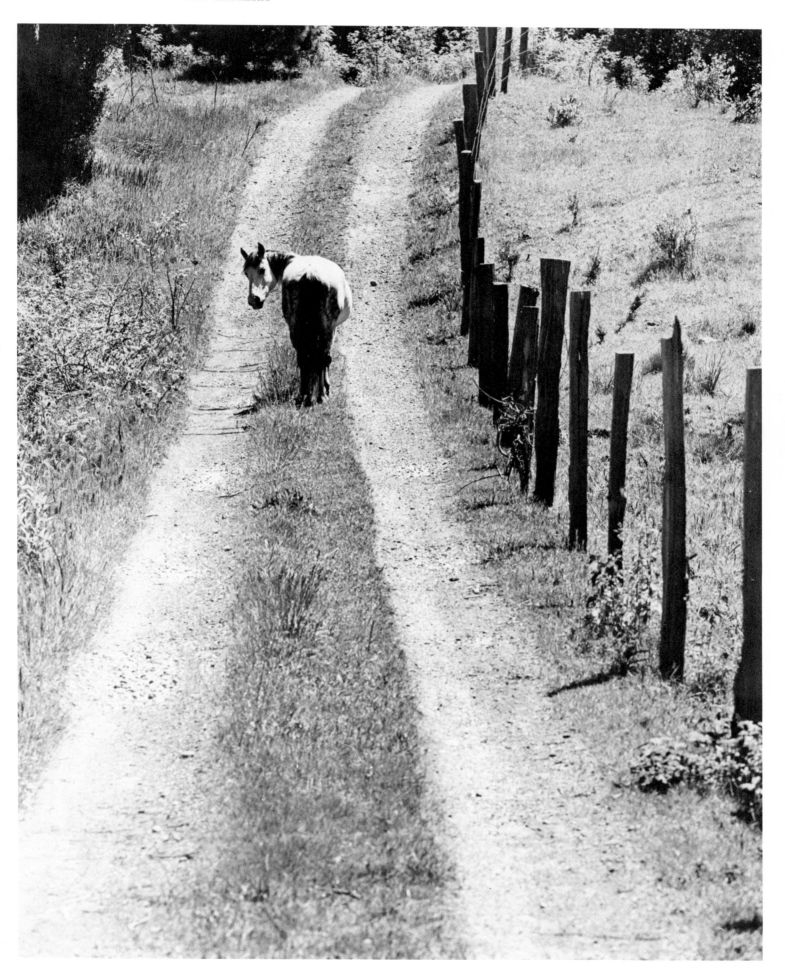

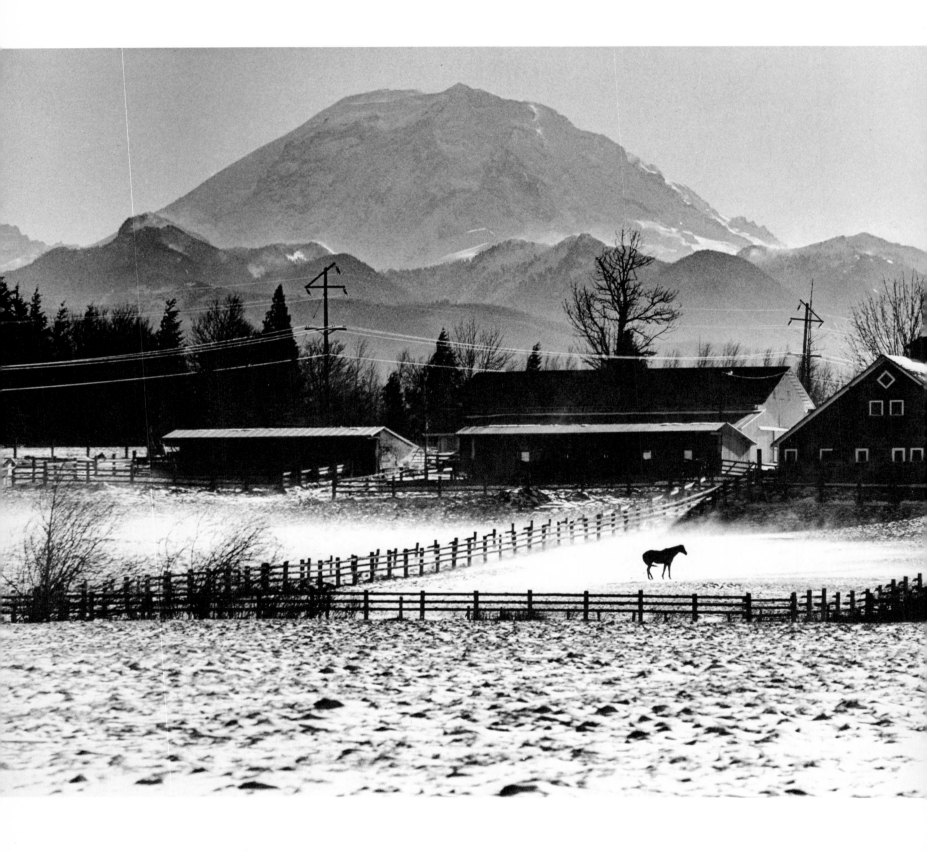

This picture, called "Cold Snap," was made to illustrate a cold day with high winds.

1/500 SEC. F 22 120 TRI X FILM
G FILTER 500 MM ZEISS TESSAR LENS
HASSELBLAD CAMERA

Whenever new snow covers the land, many ordinary scenes are given an ethereal beauty and new interpretations. The rugged terrain of this landscape is given a quiet, gentle beauty by the new snow and diffused, early-morning sun.

Early morning to midmorning and midafternoon to late afternoon light is most effective for snow photography. Midday light without long shadows produces flat pictures.

1/125 SEC. F 22
G FILTER
HASSELBLAD CAMERA

120 TRI X FILM
250 MM ZEISS SONNAR LENS

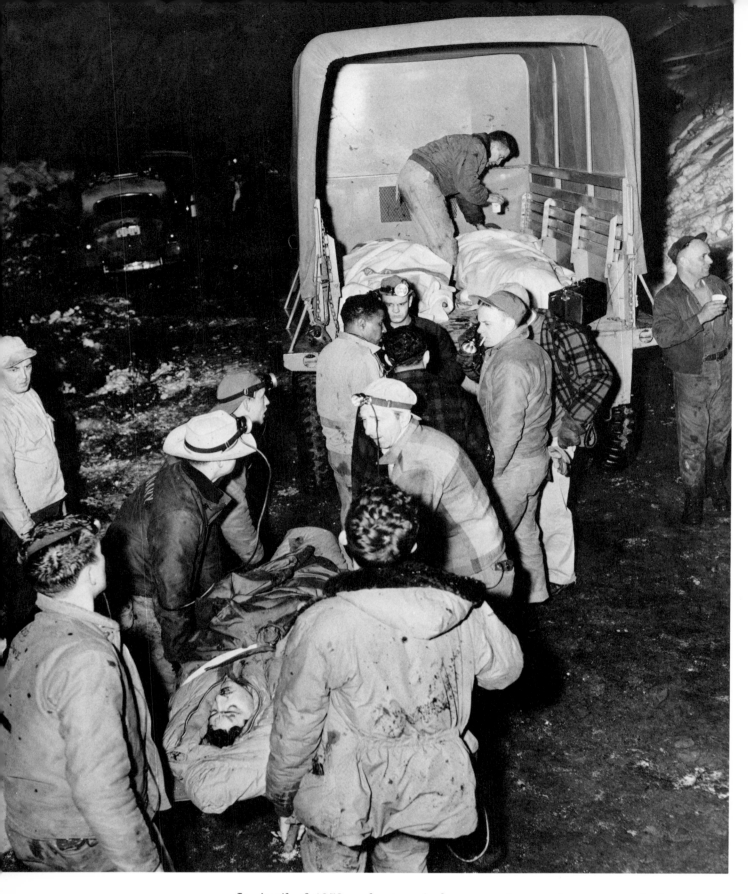

In April of 1953 a charter airplane carrying service men crashed on its approach to Seattle Tacoma International Airport.

The crash occurred in a remote and rugged area of the Cascade Mountains. The injured had to be carried several miles down the mountain side to a logging road where trucks were waiting.

The blackness of night along with sleet and rain and the fast-changing action made this a most difficult assignment.

For this overall shot, I stood on the bed of a truck and, for further height, held the flash gun high over the camera.

The 4 × 5 Speed Graphic was pre-focused at fifteen feet. A number five flash bulb was used in a highly polished focusing reflector. The subject was evenly lighted from ten to twenty-five feet.

For covering large areas, flash bulbs are more effective than electronic flash.

For flash photography, the 4 × 5 Speed Graphic is still the camera to use. I find the 35 mm camera totally unacceptable for flash photography. Even the 2¼ × 2¼ is a poor substitute for the old-fashioned Speed Graphic in flash photography.

1/50 SEC. F 11 SUPER PANCHRO PRESS FILM
4 × 5 SPEED GRAPHIC CAMERA 135 MM OPTAR LENS (NORMAL)

I was assigned to shoot the first passenger jet to fly out of Sea-Tac on a scheduled flight and try to get something different.

I placed myself along side the runway where I was told the jet would be approximately 100 feet overhead. A slow shutter speed was used for a slight blur effect to give the feeling of speed.

1/50 SEC. F 22 SUPER PANCHRO PRESS FILM
G FILTER 135 MM OPTAR LENS (NORMAL)
4 × 5 SPEED GRAPHIC CAMERA

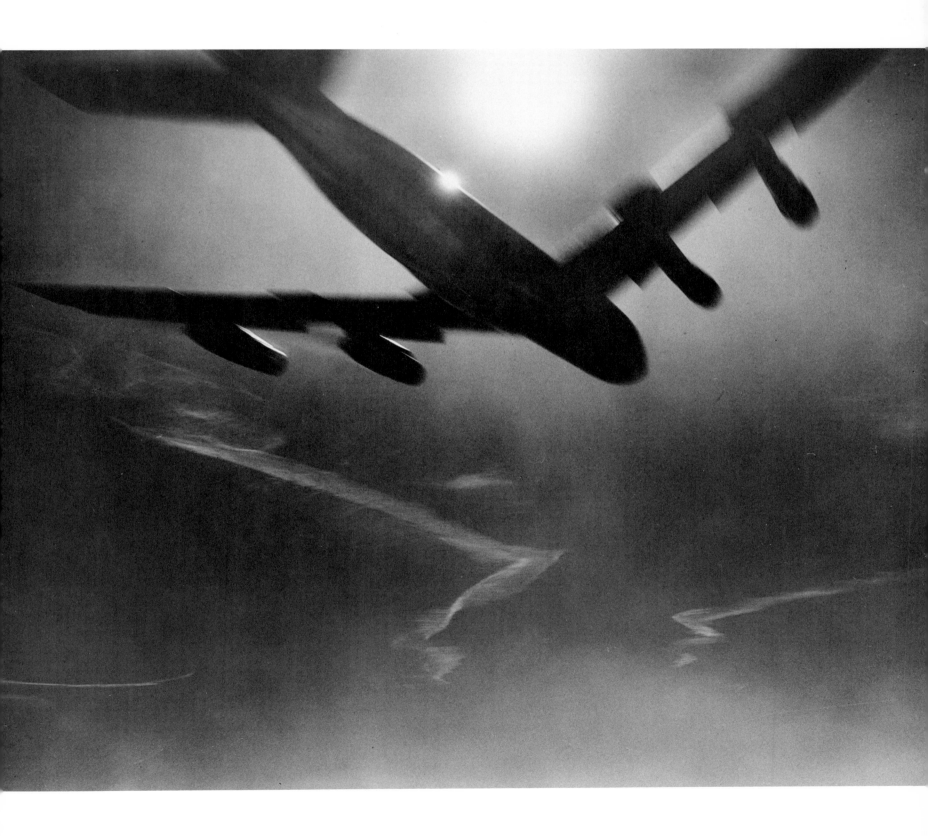

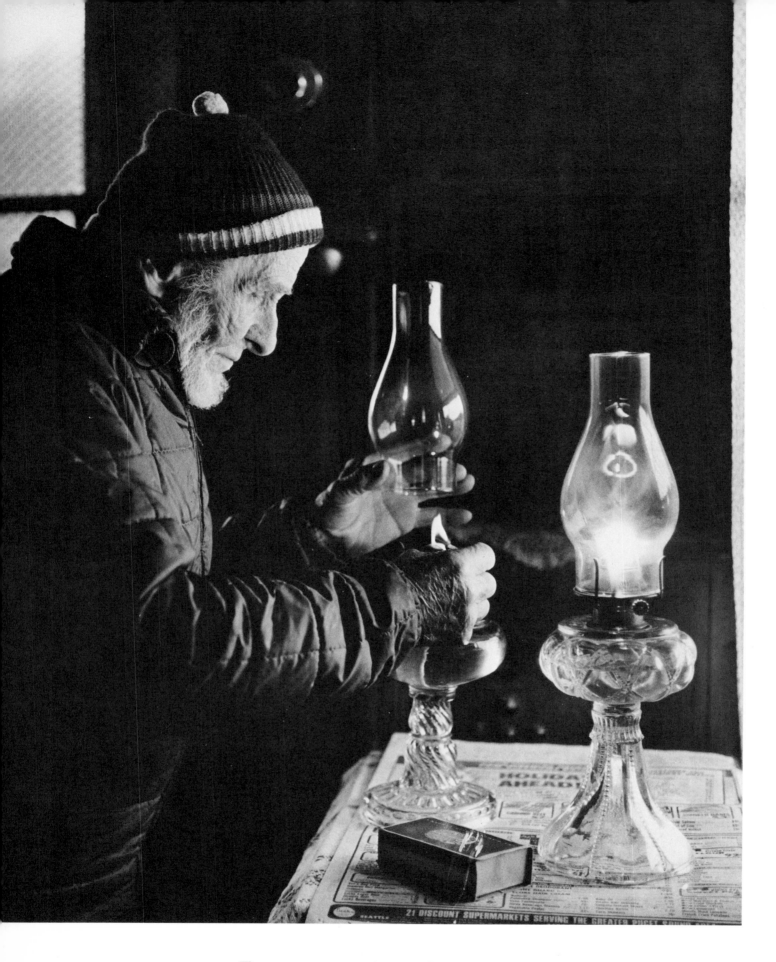

The current energy crisis posed no problems for this man whose home has no electricity and whose heating and cooking have always been by wood-burning stoves.

A newspaper photographer has many opportunities to photograph unusual and interesting people. He often learns of these people while on routine assignments.

The best pictures often come from speculative self assignments.

1/25 SEC. F 2.8 120 TRI X FILM
HASSELBLAD CAMERA 80 MM ZEISS PLANAR LENS

Here, a scene I had rejected one hour earlier as being too flat and lifeless, suddenly presented an exciting pictorial composition. The transformation was brought about by a stillness on the bay and the sun at exactly the precise angle to outline the tracery of the fish traps and the boatmen.

1/250 SEC. F 22 120 TRI X FILM
G FILTER 250 MM ZEISS SONNAR LENS
HASSELBLAD CAMERA

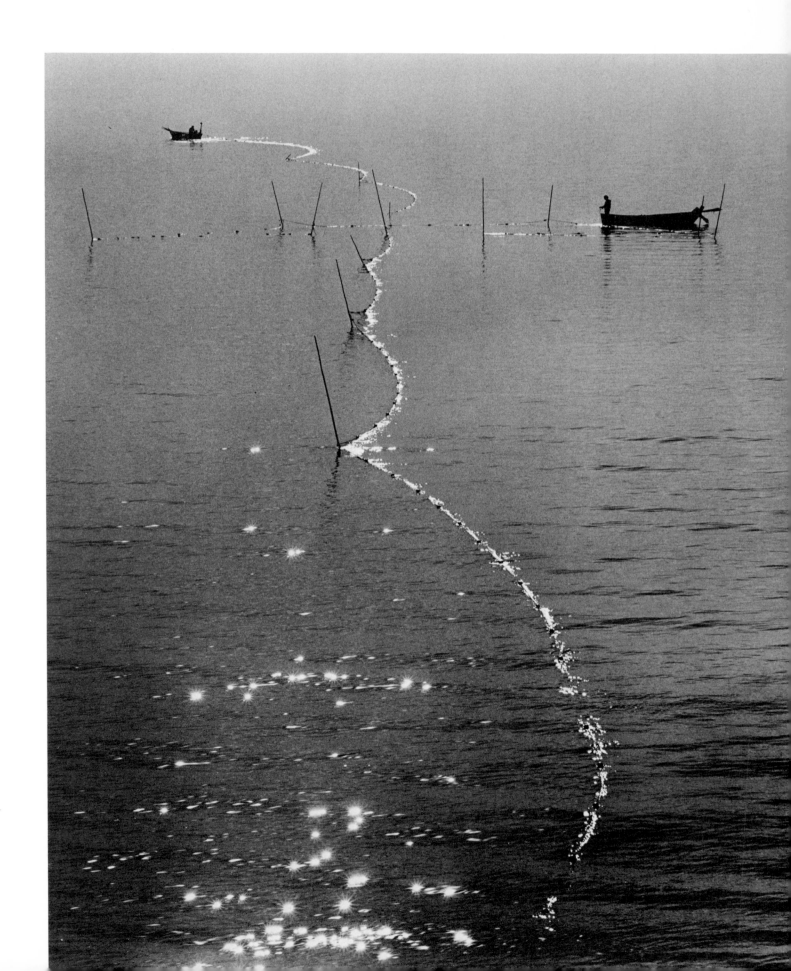

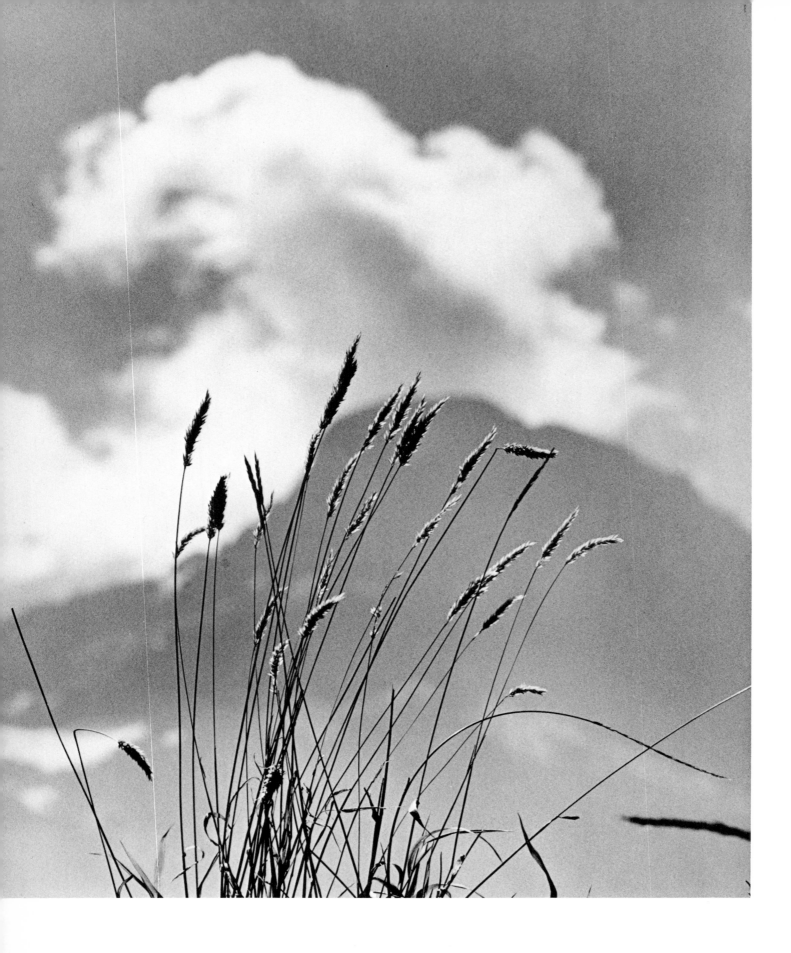

On a beautiful day shooting mountain landscapes, my attention was drawn to grasses waving in the wind. Holding the Hasselblad at ground level, I was able to place the grasses against the mountain peak and the sky. At eye or waist level, the grasses would be lost in the forest background.

The counter motion of the grasses and clouds adds movement and interest and even a dramatic touch, making it more than merely a pleasing picture. A high shutter speed and a long telephoto lens at close focus places a sharp emphasis on the grasses. The peak and clouds become a complementary mood establishing background.

1/500 SEC. F 8 120 TRI X FILM ASA 200
G FILTER 250 MM ZEISS SONNAR LENS
HASSELBLAD CAMERA DEVELOPED IN D76
 AT 25% REDUCED TIME

For my portraits as well as my scenics, I limit my shooting to Washington state. The Seattle area continues to provide me with excellent portrait subjects.

Here the background tells much about this man. The distant sea gull was an unplanned bonus.

The flash-fill was covered with a handkerchief to illuminate the face which was in deep shadow from the noon sun.

1/100 SEC. F 16 SUPER PANCHRO PRESS FILM
G FILTER 135 MM OPTAR LENS
4 × 5 SPEED GRAPHIC CAMERA

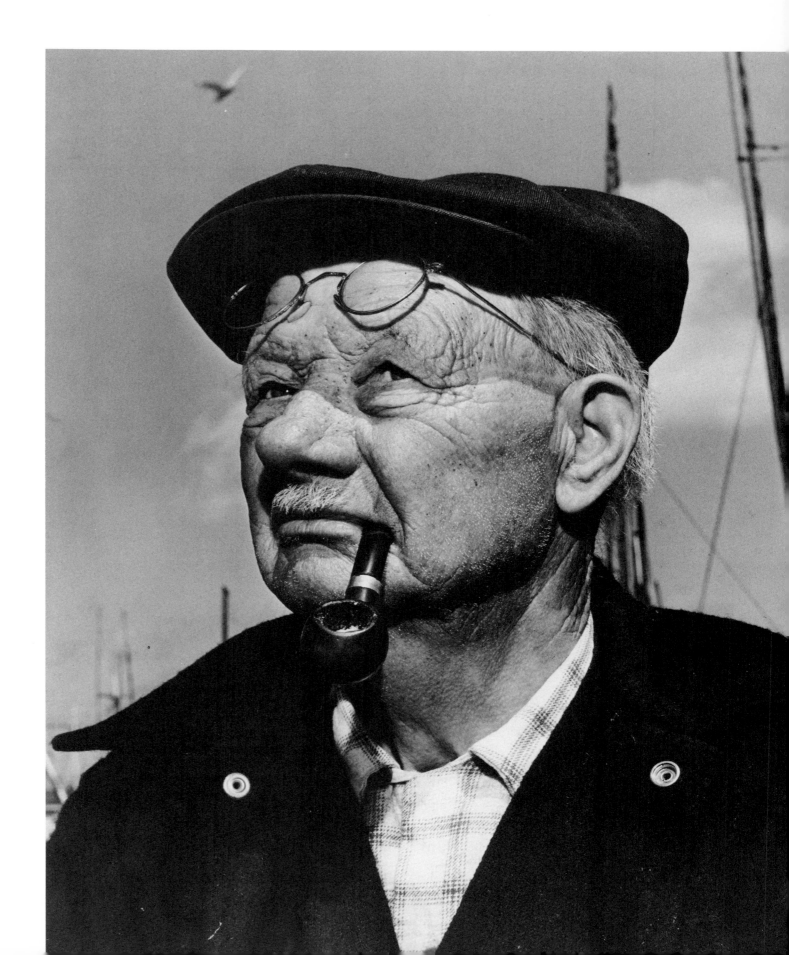

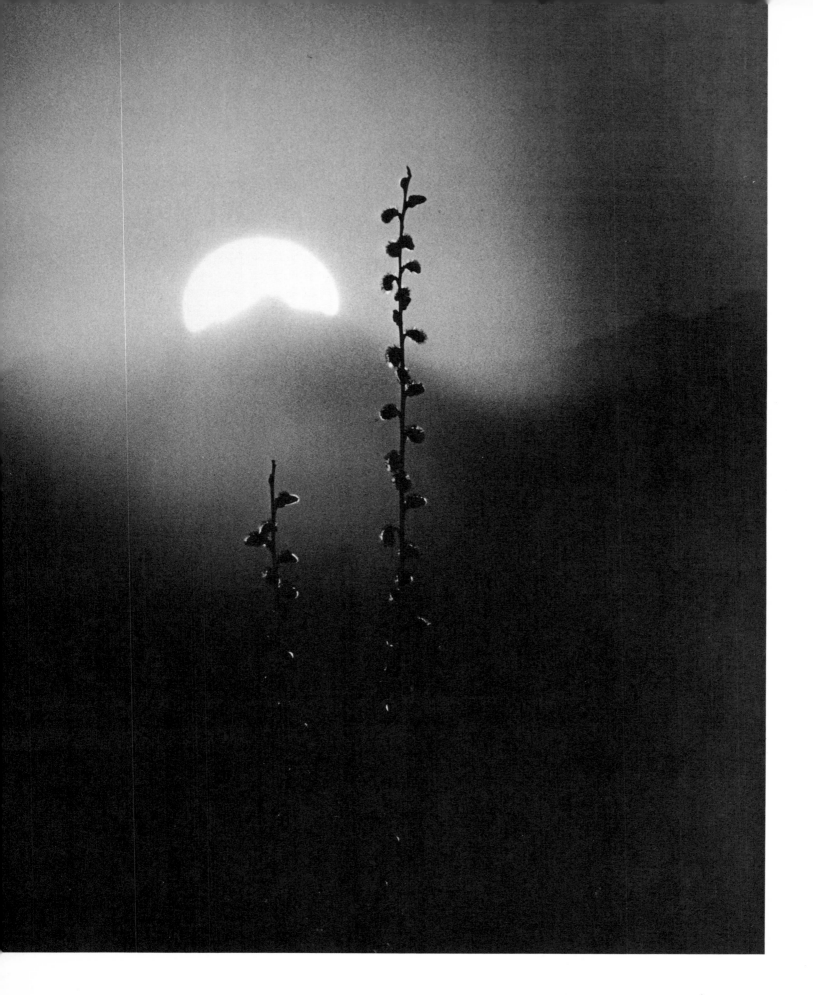

This type of picture requires a long telephoto lens. The mountains and sun
would be insignificant using a lens of less than 300 mm.

The pussy willows were thirty feet from the camera, the mountains approxi-
mately fifty miles distant. To achieve critical sharpness in the pussy willows and
reasonable sharpness in the mountains and sun, the lens was set at fifty feet at
F 32, a combination giving extreme depth of field.

1/250 SEC. F 32 120 TRI X FILM
G FILTER 500 MM ZEISS TESSAR LENS
HASSELBLAD CAMERA

SHEEP DRIVE
THE PICTURE STORY

I accidentally came upon the sheep drive while touring Winthrop, Washington. All the pictures shown were taken without a word of direction and in less than an hour's time.

I much prefer shooting a fast-breaking, unplanned picture story. When the story is planned, it is often over-scripted, over-staged, and too contrived.

Here the sheep herder with the help of his two sheep dogs drives the sheep to a new grazing area.

1/500 SEC. F 11 120 TRI X FILM
G FILTER 80 MM ZEISS PLANAR LENS
HASSELBLAD CAMERA

TECHNICAL DATA APPLY TO ALL PICTURES IN SERIES.

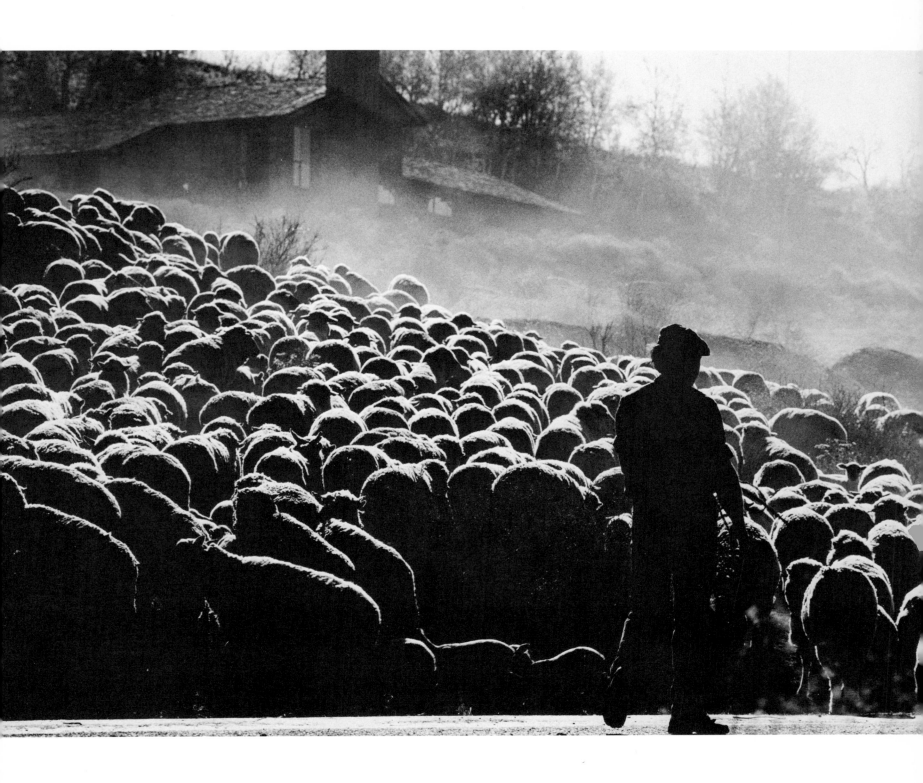

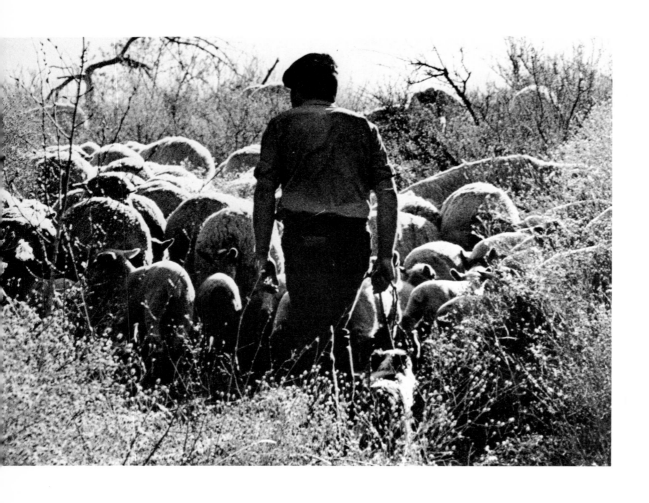

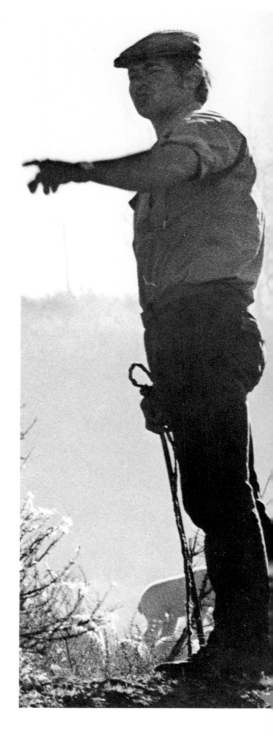

SHEEP DRIVE
THE PICTURE STORY

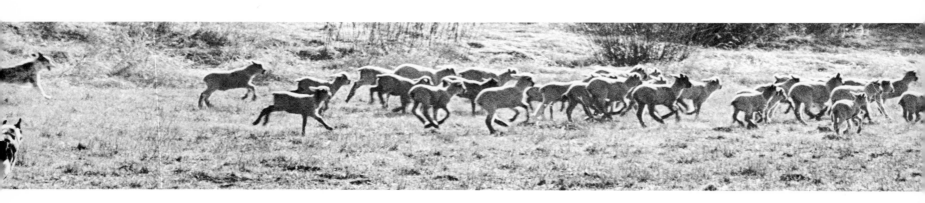

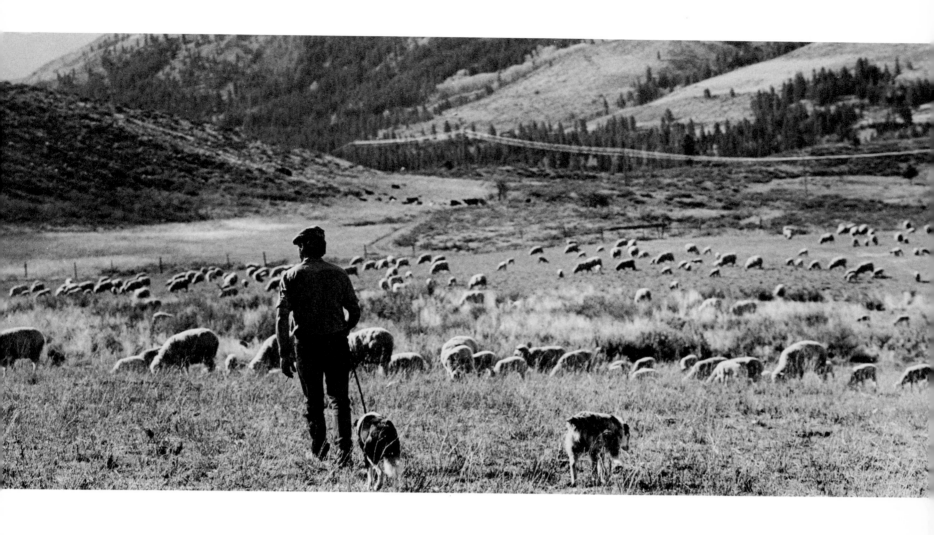

The sheep are shown settled and grazing in the new area. The dogs and the sheep herder are relaxed but keeping vigil.

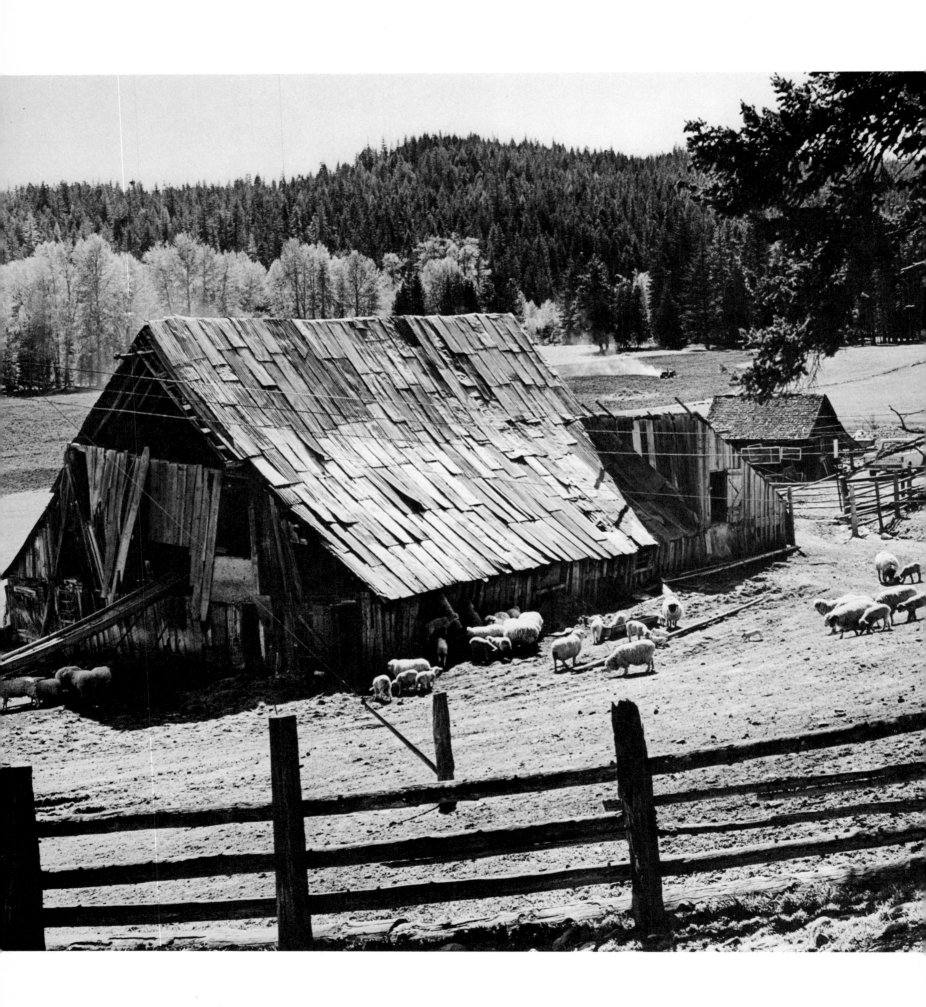

This old barn in the Teanaway Valley has become my favorite shot of 1975.

Almost every spring and autumn I make a shooting foray into the Teanaway. It is a valley of classic western landscapes ringed by pine forests and the Cascades.

The lush green fields, the grazing livestock, the farming activities, the winding Teanaway River, and the snow-topped mountains provide endless picture opportunities at every turn of the road.

So often had I worked the Teanaway, I was certain I had not missed anything worthwhile. On this beautiful afternoon in early June I found myself on a road I had travelled years before. I wasn't expecting to find anything better than I had already shot that day, but perhaps I would find something for future shooting.

I was nearing the end of the road when I came upon this old barn. How could I have overlooked this great subject on my previous visits? I began shooting the barn from every angle, making certain this time not to miss anything. After an hour's shooting, I drove to the end of the road and ten minutes later on my way back, a flock of sheep came out of the pine forested hills across the road. I immediately started shooting again and this picture with the sheep and lambs resulted.

While the shots I made of the barn alone are in some ways more dramatic, this is my favorite. The sheep and lambs, the man working in the fields beyond, give the scene life. It tells us this is still a working farm. It is not merely a relic out of the past.

1/500 SEC. F 11 TRI X FILM
G FILTER 80 MM PLANAR LENS
HASSELBLAD CAMERA

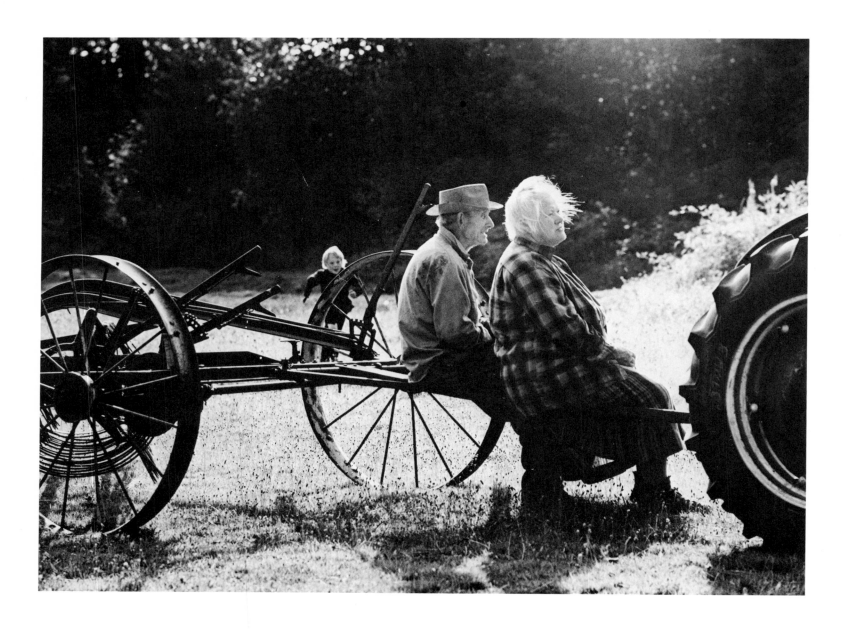

While on a tour of the ocean beaches, I drove forty miles inland to visit briefly with Mr. and Mrs. Charles Lewis, two remarkable people I had photographed several years previously.

I arrived to find them busily at work haying. Though I had planned no pictures, the scene, the setting, and the subjects were irresistible and I spent two hours shooting probably the best picture story I have ever done.

I had already put my camera away, when Mr. and Mrs. Lewis came in from the fields and rested on the machinery while their granddaughter romped in the field. I immediately went back to shooting and this is the picture used to end the eight-picture sequence.

1/250 SEC. F 11
NO FILTER
HASSELBLAD CAMERA

120 TRI X FILM
250 MM ZEISS SONNAR LENS

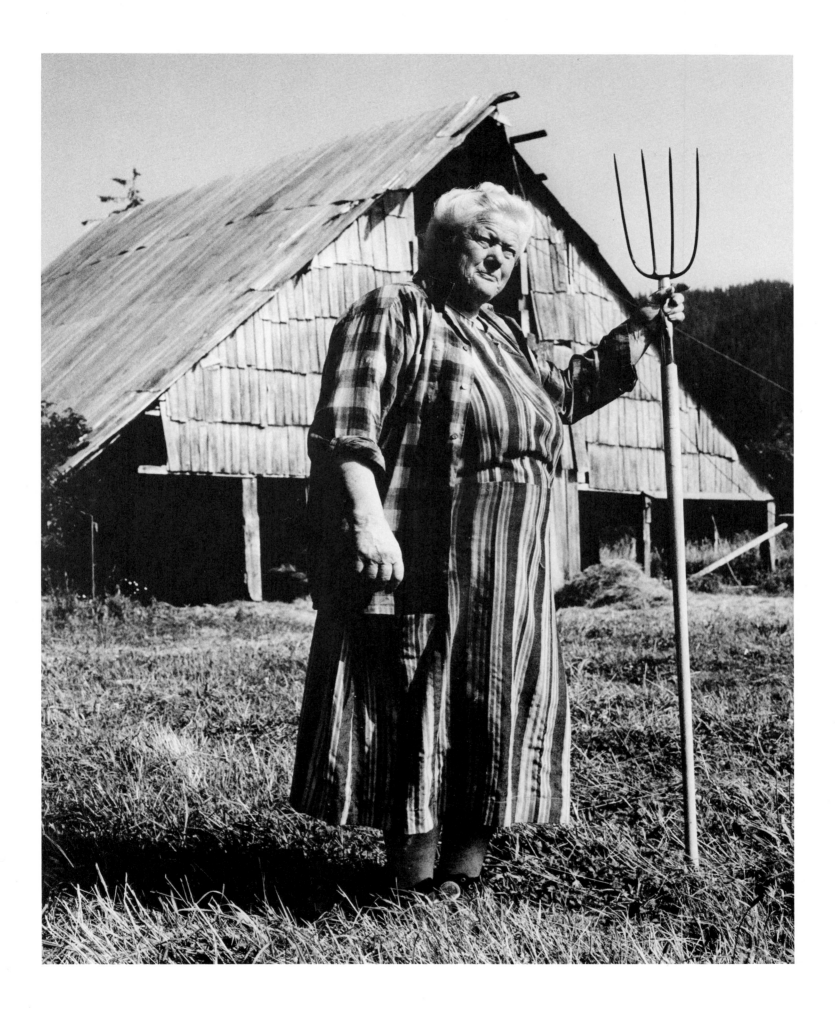

Mrs. Lewis was on her way from the barn to the fields when I dropped by. This was the stance she took while we exchanged greetings. By moving my camera position, I was able to use the barn as a most effective backdrop.

1/250 SEC. F 16 120 TRI X FILM
G FILTER 80 MM ZEISS PLANAR LENS
HASSELBLAD CAMERA

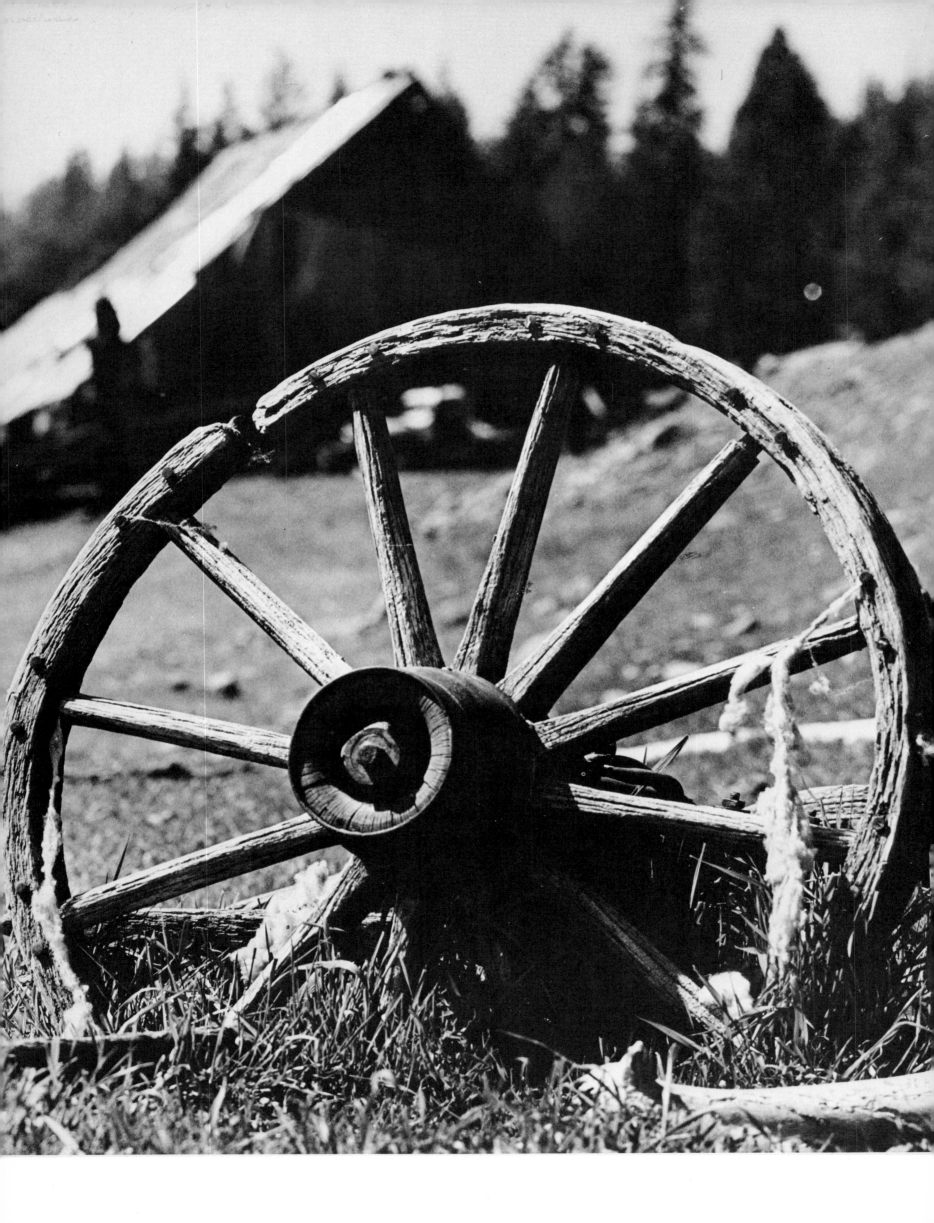

In July of 1975, I was in the Okanogan, another great scenic western area with endless picture possibilities for the photographer who takes the trouble to seek them out.

On an old ranch I came upon these remnants of days long gone. I spent several hours completely absorbed in the simple but strong subject matter.

What a satisfaction it is to the photographer when he discovers this type of photogenic nostalgia in its natural state and environment as opposed to shooting it in a museum.

I used a telephoto lens to keep the depth of field shallow. The out of focus barn creates an interesting and complementary background while not competing with the wagon wheel. The telephoto lens allows the barn to remain larger and more prominent than if taken with a normal lens.

1/500 SEC. F 8 PLUS X FILM
G FILTER 250 MM ZEISS SONNAR LENS
HASSELBLAD CAMERA

New snow and bright sun covered the Puget Sound country from the Cascades to the Olympics. Pictures were everywhere as I shot my way out of Seattle and far into Snohomish County.

By early afternoon clouds began gathering. The temperature rose and the snow lost its sparkle.

It was on my return in the Monroe area where I found my best picture of the day. The old barn under the leaden sky, the expanse of no longer fresh snow presented a somber mood, a wintry feeling with the threat of more snow and a long winter ahead. The scene, the mood, the sadness took me back half a hundred years to the winters of my New England childhood.

Weather conditions created the mood that lifts this picture out of the purely scenic category.

1/500 SEC. F 11 120 TRI X FILM ASA 400
G FILTER 250 MM ZEISS SONNAR LENS
HASSELBLAD CAMERA NORMAL DEVELOPMENT IN D 76

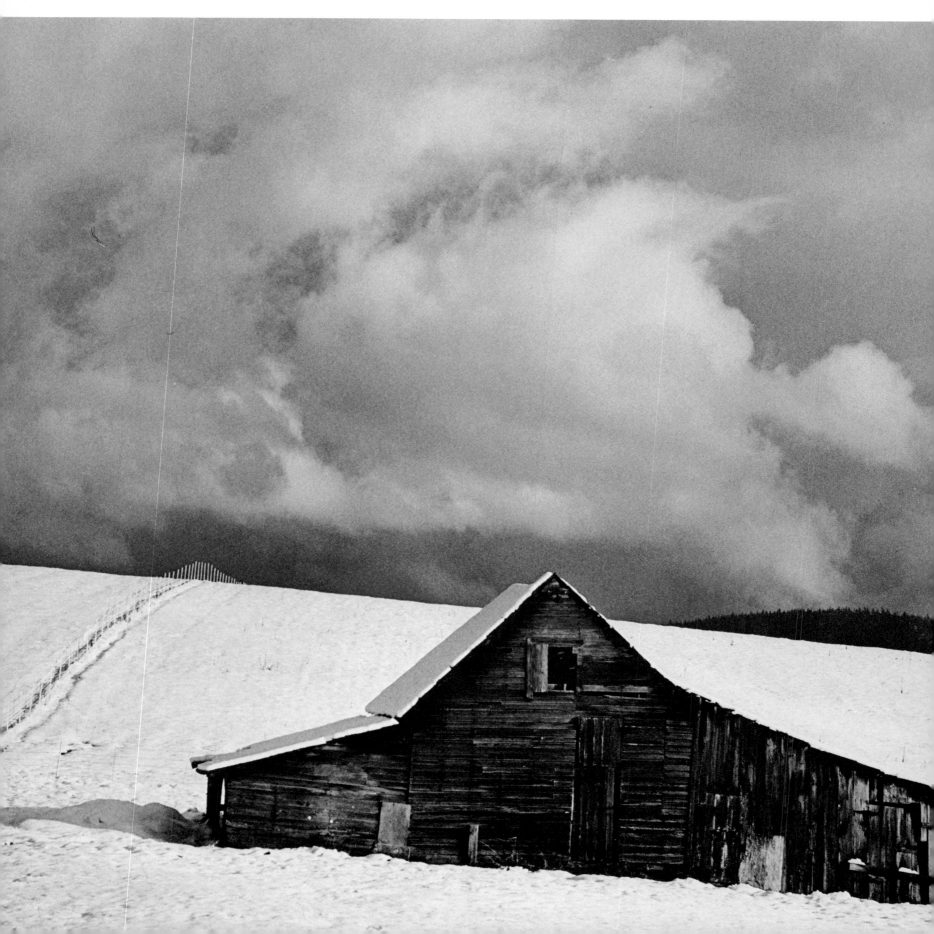